Voices of America

Madison Women Remember
Growing Up in Wisconsin's Capital

Inset image: the Wisconsin Memorial Union Terrace. (Courtesy of Anita Parks.)

Background image: the view of the Capitol from Olin Park. (Courtesy of Wisconsin Historical Society WHi-6524.)

Voices of America

Madison Women Remember

Growing Up in Wisconsin's Capital

Sarah White

ARCADIA

Published by Arcadia Publishing
Charleston SC, Chicago IL, Portsmouth NH, San Francisco CA

Printed in the United States of America

Library of Congress Catalog Card Number: 2005935601

For all general information contact Arcadia Publishing at:
Telephone 843-853-2070
Fax 843-853-0044
E-mail sales@arcadiapublishing.com
For customer service and orders:
Toll-Free 1-888-313-2665

Visit us on the internet at http://www.arcadiapublishing.com

To our mothers

CONTENTS

ACKNOWLEDGMENTS

Innumerable people deserve my thanks for their contributions to this book. There will surely be some I forget and will be apologizing to by the time you read this. Foremost, of course, thanks are due to my husband Jim, who provided all kinds of support so I might keep to the tight schedule Madison's approaching sesquicentennial imposed on this project. My mother Jean White of Sarasota, Florida, and my sister-in-law Lizette White of Austin, Texas, provided tremendous assistance with transcribing and editorial review. It was a surprise and a delight to find myself collaborating closely with my own family on this book about my adopted home.

I extend my thanks to my advisors Ann Waidelich, David Mollenhoff, and Ray and Star Olderman, for their wise counsel.

More thanks are due to the people who referred potential narrators my way: Cathy Fleming, Anita Hecht, Catherine Tripalin Murray, Anne Short, and others.

I enjoyed tremendously getting to know the narrators who contributed their stories to this book: Ruby Helleckson Hubbard, Helen Blazek Richter, Anne Stassi Bruno, Rosemary McGilligan McDermott, Anita Daitch Parks, Donna Lappley Fisker, Jackie Gregory Mackesey, Winnifred "Winnie" Lottes Lacy, Margaret Brink Ingraham, Beverly Mickelson Fosdal, Susan Schmitz, and Regina Rhyne. To each of you, my warmest thanks.

Others who were instrumental to this book's process include Hallie Lou Blum, Michael Bovre, Mark Gajewski, Marilyn Gardner, David Giffey, Julie Tallard Johnson, Gary Tipler, Bill Patterson, and the staff of the Wisconsin Historical Society Image Archives. Thank you all.

My thanks go to Arcadia Publishing for accepting the book proposal and to Ann Marie Lonsdale for editing. More thanks go to the Madison Arts Commission for supporting my oral history project with a sesquicentennial grant.

To you, the reader, go my closing thanks. You chose to pick up this book, and I hope you find it worth your while.

INTRODUCTION

Open these pages and celebrate Madison's 150th birthday with 12 women whose roots go deep here. Get to know their families and friends, and enjoy their pastimes, as you follow them through an adventure we all share: coming of age.

This cast of characters has come together by design and by magic.

With Madison's sesquicentennial approaching, I thought of a birthday present I could give the city: a collection of oral history interviews to reveal the changing nature of Madison over time. I imagined a book composed of women's voices, describing experiences from early childhood through leaving home, because coming of age at a particular place and time leaves such an indelible mark on us. I hoped to gather stories from about 1910 to 1970, from women's suffrage to Gloria Steinem.

I asked local historians and friends for referrals to "women with an interesting story." A brief article about my quest appeared in the *Capital Times*. Before long I had about three dozen women interested in my project. I charted birth dates, neighborhoods, and ethnic origins. I looked for a broad cross section of circumstances and experiences. With help, I have conducted and transcribed dozens of conversations and edited them into chapters, each presenting one woman's story in her own words.

The chapters appear in chronological order. I have not inserted my own voice, choosing to show rather than tell what has struck me as wise, poignant, universal, or simply amusing. I found fascinating threads weaving through the fabric of these stories, and I hope you will too.

The stories that appear in this book are excerpts from the material I have collected for the "Madison Women Remember" oral history project. The photographs have been gathered from the women interviewed, other local historians, and the Wisconsin Historical Society Archives. The interview tapes and transcripts, reviewed and approved by the participating women, are archived with Historic Madison Incorporated.

I hope you find inspiration in the wisdom, grace, and pleasure these women bring to their lives, as I have. If you like your history in the first person, you will find interesting reading here. If you are new to Madison, this book might help you put down roots. Most of all, I hope these women's stories motivate you to tell your own.

I received a grant from Madison Arts Commission to share this oral history collection beyond this book. I hope these women's wonderful stories can contribute to other sesquicentennial events and projects. I will be bringing these stories to schools, neighborhood centers, seniors programs, writing and drama groups, and more. If you are interested in a presentation about the collection, or would like access to the transcripts for your own cultural or artistic pursuits, please let me know.

Sarah White
50 S. Fair Oaks Avenue
Madison, WI 53714
http://www.whitesarah.com

One

Ruby Helleckson Hubbard, Tenney-Lapham Neighborhood

My name is Ruby Esther Helleckson Hubbard. I was born in 1915 on a farm in Mount Horeb. I lived at 940 East Mifflin from the time I was seven (1922) until I was married in 1934, and before long I was living next door, and I still live in that same house today.

My earliest memory comes from when the First World War was over. When the men came home they would walk up and down the street, greeting each other, I suppose in disbelief that they really got back.

Family life around the home

I was the second-oldest. I had an older brother, Carmen, then myself, then my sister Laurene, then my brothers Palmer, Burnett, and Duane. My sister and I had the back bedroom, and the boys had the front bedroom. When it was hot we used to sleep on the porch.

We had a water heater in the bathroom. Before you took a bath, you would turn on the gas underneath it, and then when you got to taking a bath, you would shut the heater off. You could not let it run all the time. In the kitchen you had to heat water on the stove. We had those big old teakettles.

We did not have an automatic washer. We had a big tub machine with electric motors and wringers. It had two tubs to fill with cold water to rinse clothes. If the water was too hot, we used a broom handle to take clothes out. Then we would rinse in the first cold water, then run through the wringer into fresh cold water in the last tub. Then we put the clothes in a basket and carried it outside to the clothesline where we left them to dry. After that we folded some, and the rest we had to iron. At first we used a flat iron that we had to put on the stove and heat. Later the irons were electric.

We heated with coal. We had a coal room in the basement, next to the furnace. Coal was delivered by truck through a window that opened onto the driveway. His truck had a chute that fit in the window that they pushed the coal down.

Family get-togethers in Mount Horeb

Dad used to take us to my Grandpa's every Sunday in Mount Horeb. My dad was the first one in Mount Horeb to have a car. Ours had side curtains, no rolling windows. The top would roll back. And then if it was real hot, they would take the curtains off.

We really loved the farm. On Sundays, the minister would always come. Every time there was a holiday, the whole family would get together at one place. You would have to set the table up twice or three times, because there were so many of us there.

When we went to the farm, we had to carry buckets full of water downhill from the pump. We would start out with a full bucket but only have half when we got to the bottom. The outhouse had two holes for seats. We used the Sears catalog for toilet paper. It was not glossy then. It was softer paper, like a newspaper.

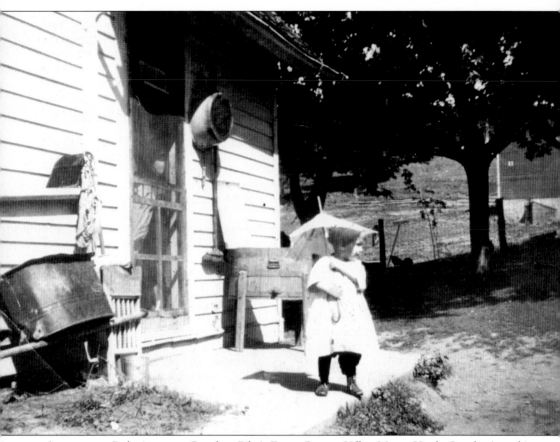

A very young Ruby is seen at Grandma Bilse's Farm, German Valley, Mount Horeb. Grandma's washing machine stands against the house. (Courtesy of Ruby Hubbard.)

In the depression, money was tight

My mother took in boarders. We had three men in one room, and women in the other two rooms. And we had one bathroom, for all those people. Nobody complained. We kids would sleep in the living room. My mother and dad used to sleep on the porch. It was a hardship. But you did not think about it, because everybody else was poor.

We kids had the dishes to wash, so we were kept quite busy. When I would come home from school, I would have to bake a cake, to have dessert for the people when they came in.

We had people from all the small towns. They came for jobs. Some worked at the Burgess Battery Company, right over here on Brearly Street, and at Gardner's Bakery.

My neighborhood: Breese Stevens Field

When the Capitol Theater burned, they hauled the rubbish down here. And then the gas and light company hauled their coal ashes out here. That was what filled up a lot of these blocks. I vaguely remember that we had wooden sidewalks. It was muddy.

Breese Stevens Field stands across from our house. I remember them building it, the way it is now, in 1934. It was a Civil Works Administration project. Before that, it was just a dump there, about six feet lower than the street. There was water in there, and rats. After it was filled in, they built wooden bleacher seats on just this one side.

All the high schools played their football there, for many years. At the end of football games they would always shoot off fireworks. We would go out and sit on my parent's porch roof, so we could see over there.

Dad's gas station, a great place to meet boys

At first, my dad was in a garage on University Avenue, with a partner. Then my dad bought a lot at 1002 South Park to build his own gas station.

My brothers worked for him when they got old enough. I do not think any of them minded. In those days there weren't many other jobs they could get.

My mother and my sister and I always went down to sit with my dad when he was open

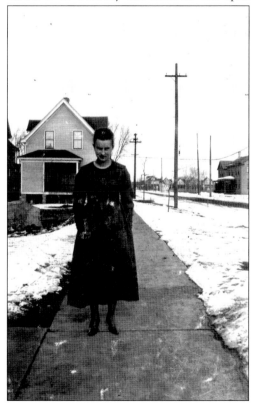

My mother's sister Elizabeth is in front of our house. Look how empty the area was back then! Breese Stevens Field would be just beyond the frame to the right. (Courtesy of Ruby Hubbard.)

11

This view is of Grandpa Bilse's farm in German Valley outside Mount Horeb.

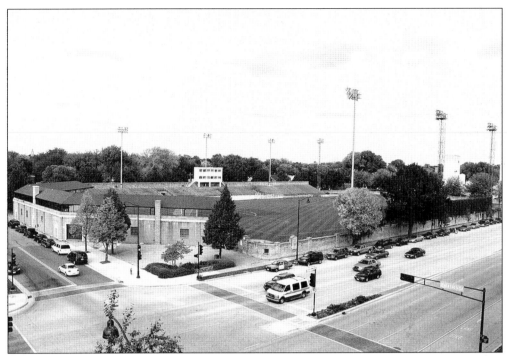

Breese Stevens Field is seen here in 2005. Ruby's house is located on the wooded street just beyond the structure. Built in 1925, the facility served as Madison's major athletic complex for decades. The wall was erected in 1934 of sandstone quarried near Hoyt Park. (Courtesy of Steve Agard, Hyperion Studios.)

at night. That's how we met all the boys. I met my husband, Juel, there. My brothers' friends would come around. They had cars, and we went out riding with them.

We used to go to the A&W Root Beer stand down on Park Street. That's when you got nickel root beer. Didn't take you much to go with somebody, they never had a lot of money either.

Those boys were really nice! We would just ride around, probably along the lake. You could go out into the country too. Juel lived in McFarland, where his family owned a hardware store.

Marriage

I was married in 1934, right after I got out of high school. We were married in St. John's Lutheran on a Saturday night, and then we came back to my folks' house, and we ate, and

then we went over to his brother's place. We didn't have a honeymoon, couldn't afford it.

We rented one of the bedrooms there. We had a roll-away bed that folded up, and we'd open it up at night. And the closet was where we cooked. Who would put up with that today?

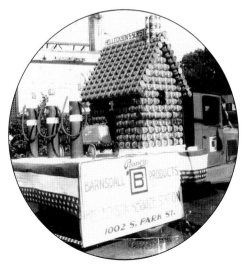

Ruby's father's gas station sold Quaker State oil. The family and friends built this float for a parade, and got first prize for it. (Courtesy of Ruby Hubbard.)

13

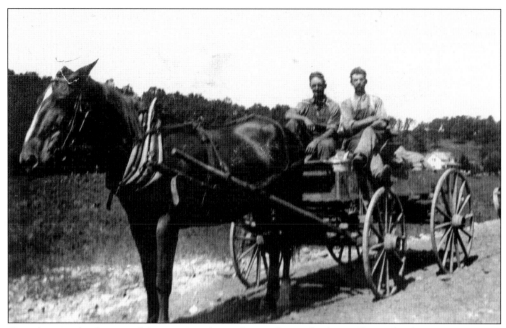

Seen here is the horse and buggy Grandpa Bilse used to take his milk to the dairy. (Courtesy of Ruby Hubbard.)

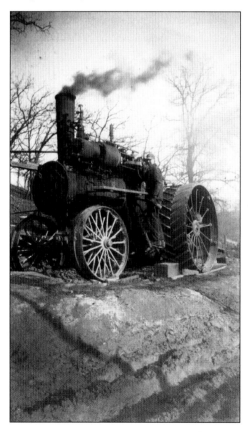

A steam tractor is seen on Grandpa Bilse's farm. (Courtesy of Ruby Hubbard.)

In 1939 we bought the house next door from our neighbors. We took in roomers then, and some became good friends for life.

Ruby and Juel Hubbard raised three children in the house next door to her childhood home. Juel continued in the hardware business, operating Hub's Hardware near the corner of Paterson and Johnson Street. Ruby worked outside the home in sales and later for the University of Wisconsin as a telephone operator. She remained active as a volunteer with her children's schools, the Royal Neighbors insurance society, and with her husband in the Masons. The family enjoyed camping trips, bowling, and other activities together. Ruby now joins friends at the Wilmar Neighborhood Center regularly, and assists with fundraising for the center.

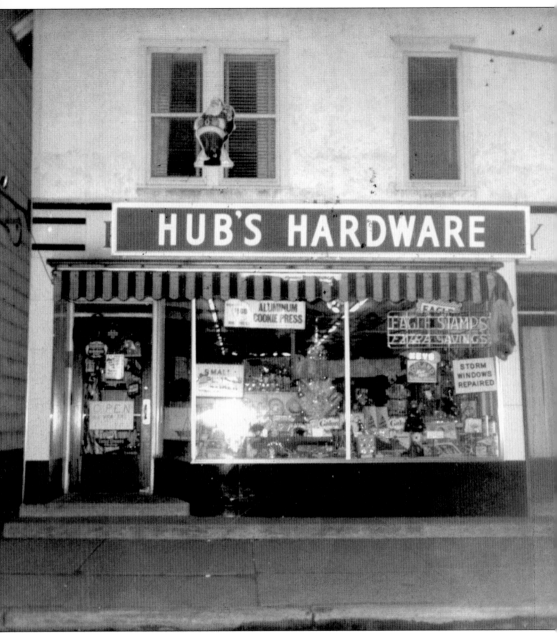

Hub's Hardware Store, operated by Ruby and Juel Hubbard, is seen here in 1957. (Courtesy of Ruby Hubbard.)

Two

HELEN RICHTER, WEST DAYTON

My name is Helen Blazek Richter. I was born in 1916, and in the summer of 1917 my parents moved to Madison. My father was a conductor on the Chicago-Milwaukee railroad. His layover was in Madison, and that is why my parents moved here.

We lived at 927 West Dayton Street, right down by the Illinois Central tracks. That was just north of what they called the Greenbush; the railroad tracks were the border between their neighborhood and ours. In those days, there was some bootlegging going on down in the Greenbush. I remember there was an explosion in one of the houses one night. We used to go over on Park Street, which is where the first pizza joint started, Paisan's.

Daddy's pet

My dad was home every other night there for a while, and then after he got promoted to conductor on the "passenger," he was home every day. I was his pet, of course. Spoiled.

I always said when I was young, when I get married, I'm going to have kids. I didn't like being raised alone, and I figured I had missed something in life. Fourteen years after I was born, I had a brother, but I hardly knew him. I was in high school by that time.

Travels by train

Lots of times, I would rush home from school, we would get on the train, and we would go to Prairie du Chien to visit my father's mother there. I traveled a lot on the train. The railroad gave you a free yearly pass—that's why we could travel like that.

On occasion, my parents would take me to Chicago for the day. We would go in the morning. You would get off right downtown and go shopping. That was fun.

My parents' different worlds

My father was Bohemian, my mother's people English and Dutch. His family was in Prairie du Chien; hers was in MacGregor, Iowa. My father was Catholic; my mother was raised Methodist. She turned Catholic when she married, but she never forced the religion on me. I did go to Saint Raphael's. When I was ten years old, my grandmother in Prairie du Chien said I had to come down there and go to their Catholic school, to receive my first communion. I wrote with my left hand until then. That is where the nun slapped my fingers, made me learn to write all over again with my right hand.

My mother came from a wealthy family in MacGregor. They had a big 16-room house. I used to enjoy going over to MacGregor. My grandfather and Teddy Roosevelt, before he was president, were personal friends. He used to tell me the stories about riding with the Rough Riders, out in Dakota! My grandfather was a farmer, and invested in the stock market. In his later years, he was one of the wealthiest men in MacGregor.

On my father's side, they were common people. The only time Grandma would dress up would be on Sunday. When I went down there in the summertime, of course we had an outside toilet. And we carried water in for Grandma all the time.

With these two families, I had two different ways of living. It always made me think, why?

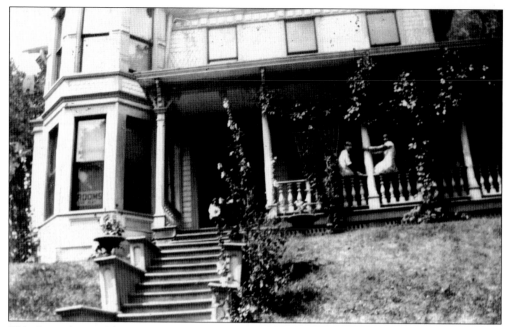

Helen's grandparents' house in MacGregor, Iowa, is seen in this photograph. In the summer, the family would rent out rooms to tourists. (Courtesy of Helen Richter.)

Why do some people have so much more than others?

Evening shopping on the Square

We used to go to the Garrick Theater just off the Square every Sunday night when I was a young girl. We would stop at the YWCA on West Washington Avenue for supper first.

After we ate, we would go to the Badger Candy Kitchen to buy candy—three pounds for a dollar, chocolate. My dad would always let me have a pound, anything I wanted, and my mother could have two pounds. That was our Sunday night.

We used to go to the Kresge's dime store on the corner of Main and Pinckney Streets, they used to have the best peach pie!

From the Depression, lessons in charity

I lost all my money, it was in the Commonwealth Bank, and that bank never opened again. My Grandpa in Iowa used to say to me, "Helen, if you've got a dollar, save some of it." I had around $1,200 in the bank that I lost. Quite a bit of money it was, in those days. There was a lot of hardship, a lot of homelessness in the Depression. The railroad tracks were right behind us, and we used to have knocks at our back door—it would be the bums. My mother would feed them.

My father was always helping people. We didn't learn that until he died. The letters we got from people saying how he had given them money, when they didn't have it.

Despite hard times, good times!

My mother made everything I wore. We would go downtown and go to Simpsons or Manchesters. I would see something I liked, and within three days, my mother had made it. She was a dressmaker—very, very handy. I never had a boughten dress, nor a slip, nor under-petticoat. My mother made those, and she would even make lace, crocheted or tatted, to put on them.

Up until I was 16, I never had a boughten thing, and I didn't like that. When I was 16, I went downtown and saw a dress I wanted. I bought it for $1 down, $1 a week. It cost $16, I think, it was expensive, that was a lot of money.

Oh, I used to just love to dance! And do the Charleston, especially. I would always go dancing on a weekend, down on State Street. Never had any dance lessons, just

The Garrick Theater was located in the first block of Martin Luther King Boulevard, then known as Monona Avenue. (Courtesy of Ann Waidelich.)

Helen is seen here at 16 years old, in front of her house. Helen recalls this is the first store-bought dress she owned. (Courtesy of Helen Richter.)

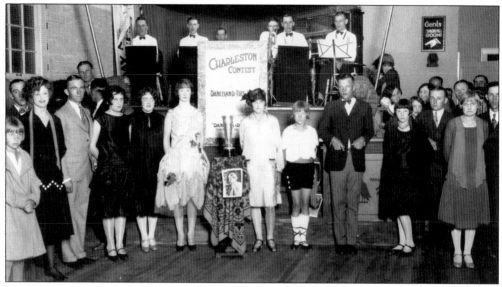

No photograph was taken at the contest Helen won, but she recalls the contestants were dressed very like the young people in this photograph, the place and date are unknown. (Courtesy of Wisconsin Historical Society, WHi-11716.)

learned at the dances at Central High. When I was 16 I won a Charleston contest at the Orpheum Theater.

In Sun Prairie, at Angell Park there was a dance hall where they had the big orchestras. We would find one fellow with a car, and we would pile in, and away we'd go to the dances.

I didn't go out with too many boys in my teenage years, because if I went to a dance with one of them, I would have to dance with him all night! Where, if I went with a few girls, we had a lot of fellows to dance with. We had more fun that way.

I went to vocational school. I studied typing. After I got out of school, when I was 18, I used to do waitress work in the 'Bush. It was interesting! I love people.

When I was young here, people were friendlier—a lot friendlier. I don't care for these shopping centers. I would love to just go downtown and walk around the Square again, be able to shop Manchesters, Barrons, and Simpsons.

Helen married shortly after graduation and bore two girls, Barbara Ann and Nancee. A divorce left her on her own until she met and married Oscar Richter who, with his love for Helen's children, made the family whole again. In the 1950s, three boys joined the family: Gordon, Richard, and Jeffrey. Helen enjoyed a career working in catalog sales at Penney's department stores. Later Helen and Oscar enjoyed extensive travels. Today, Helen maintains a busy life filled with card parties and socializing with friends. She is noted for baking banana bread to share.

Three

ANNE BRUNO, GREENBUSH

I am Anne Bruno. My name was Gaetana Stassi, but "Gaetana" got shortened to Anne.

My people are from a little place in Sicily called Piana degli Albenese, which is "Village of the Albanians." There are a few of us here in Madison.

My father and mother were both Italian-Albanians. They were born there in Piana. My dad came in 1914, I believe, and my mother came about the same time. They did not know each other. They met through the Italian Workman's Club, no doubt. It was a social gathering place.

I was born in 1916 at the corner of Park and Regent Streets, in a three-story house. My sister Mary is three years younger than I am. Then, most women had their babies alone. Few went to the hospital. My mother said we were both born at home, helped by tenants of the building. Later, the doctor would be notified and he would come to make sure the mother and baby were doing all right.

I often asked my mother how I lost my finger. She said they were getting together for a celebration at my aunt's house, down Regent Street. The ladies were sitting around this large, round table, doing little things, preparing food. My aunt had 10 children. They were all scooting around, having fun, and I was under the table. My mother was using a meat grinder, grinding hard bread to make bread crumbs. My middle name must be curiosity. As she stopped to talk, I put my finger into one of the holes. It just fit in there. Immediately she started to crank, and heard me yell. She said she cut off just the TIP of my finger, as far as they could see. And so my dad carried me up to Madison General, and Doctor Ganser said

that, because that article was used for meat, he was going to be overly cautious and cut down to the second joint. And he did a very poor job of stitching it off.

Happy but protected childhood

I always had other children to play with, and we were always into something. Roller skating or hide-and-seek, just anything you could do near your home. We played with dolls, played house. We would take care of younger children, like the Schiavos' next door. They would be assigned to us to keep them occupied while the parents were busy.

By the time I was about eight or nine, my dad had bought a house just a half a block away from West Washington Avenue, across from the railroad roundhouse. All our friends and neighbors lived nearby, on Lake Street and Milton Street, and West Washington Avenue from Regent to Park Streets.

We weren't permitted to learn how to ride a bike. A friend of ours came over and had a bike, and he said that he would take us for a ride on the handlebars. My sister was a little more courageous than I was, and he took her around the block. When my father heard about that, there was, as we say, hell to pay. We never did learn to ride a bike. That was always a disappointment.

We didn't bathe at the beaches—that was a no-no. Just something we did not do. Later, after marriage, we frequented the beaches.

My mother was a very social, affable, loving woman. Everyone who knew her loved her. The women's social life was visiting each other at their homes, or getting together for a birthday or a wedding.

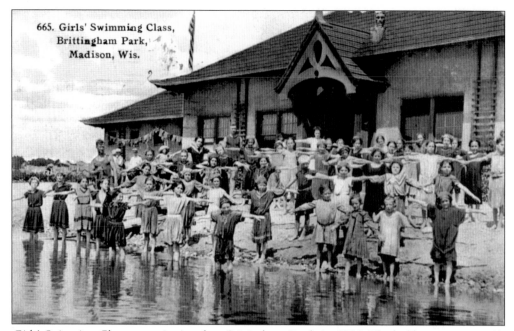

665. Girls' Swimming Class,
Brittingham Park,
Madison, Wis.

Girls' Swimming Classes were instituted at Brittingham Beach in 1905. The bathhouse was set aside on Friday afternoons for the exclusive use of girls. Unfortunately, Anne was not allowed to swim there. (Courtesy of Ann Waidelich.)

People wouldn't really go out to eat unless it was a special occasion. They were more into picnics. Italian sausages, or hot dogs. We would go to Hoyt Park, or to Brittingham (it was called Columbus Park when we were young; they changed it to Brittingham later). Or we would go to Devil's Lake and picnic there. We would go by car—by then people owned cars, and they would follow one another out to picnic. We all had little box cameras and snapped pictures.

Wedding receptions took place at the Italian Workman's Club Clubhouse. I think it was founded in 1848, one of the oldest in the country. The mothers would be there, the children—you would put them on the pool tables, and cover them up with a little blanket. The music went on and on. At first the festivals were held on the street. The city would block off the street in front of the clubhouse.

In Greenbush, the parents' world

My father was in construction. He worked for John Icke, for Findorff, he worked for all the local construction firms. He was a cement mixer. For most of the Greenbush men, construction was the main job available, unless you were specially trained before you came to the States. Many worked for the city, digging ditches, or paving sidewalks, because the city was growing. They built Hoyt Park; they built the stone wall that's there and the building. They built the tower at Roselawn Cemetery.

My mother, before she was married, worked at the Lorillard tobacco factory on Bedford Street. A lot of women worked there.

As far as education, my mother went up to third grade, and I think so did my dad. That is as far as they got. They learned to write, and read. When Dad set out to get his citizenship papers, we would coach him. He passed with flying colors. My mother would go to Neighborhood House to learn the language, and she was also coached by my sister and me.

My mother was into cooking and baking; that was her forte. Whenever I was able to be at home and watch her, she would teach me. She would say, "You put your hands to it, too. Get the feel of it." Or her friends would make something that my mother did not make, and she and I would go and observe, and we would learn. I was fascinated by what they were doing!

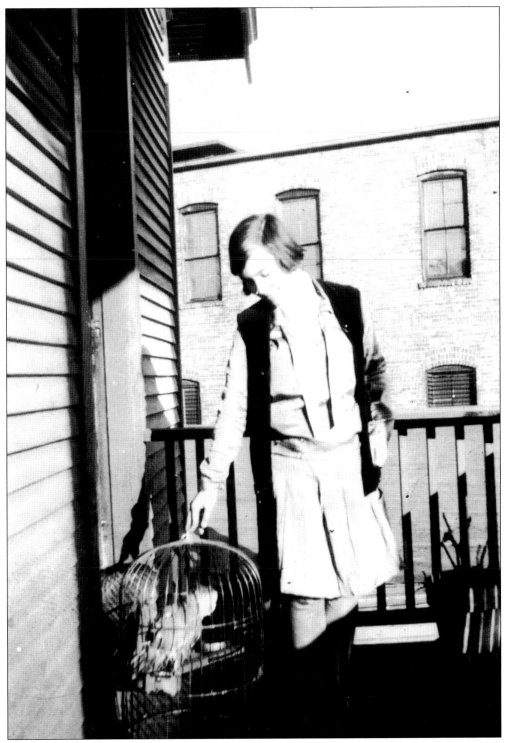

Anne's sister Mary and her parrot, in back of the Regent Street house, are seen here around 1930. The Forsberg paper box factory is visible in the background. (Courtesy of Anne Bruno.)

Anne, at about 16 years old, is seated with her mother outside her house. (Courtesy of Anne Bruno.)

My mother was noted for making rice balls, which are a specialty of the Albanians. I learned to make them, and I taught my daughter-in-law to make them. You put hamburger in the middle and deep-fry them.

All the men would make barrels of wine when September came around. They all made their own. We had a basement just equipped for making wine. Made beer once and the bottles all exploded! That was the end of that! Men would go together to order boxes of grapes and we would all help stamp it.

Everybody had a small garden. My dad had a grape arbor, and tomatoes, and cucumbers, eggplants, and squash, just a little yard in back. Everybody's backyard had a little place where they could raise vegetables.

St. Joseph's School with the nuns
I started at St. Joseph's School in 1921. My mother said the nuns would come to each home and they would bundle us when the weather was cold. They had big shawls to wrap us in, and they would take us to their convent, and teach us, whatever basics there were. The men helped build the church, and then school was in the basement of the church. The nuns lived in a rented house across the street from the school.

The nuns were our role models. Their order was Our Lady of Saint Mary of Providence. Many of us girls went through a period where we thought we might have a vocation.

They were very eager to have us visit them. A couple of girls would go with me; we would go visit on a Sunday. They played records for us on their gramophone, and gave us little treats. They had fun! They would chase each other around—to show us that they were not the somber nuns we always met in classrooms.

They wore a long black habit and a black half-cape, and they wore a pleated bonnet. They had a little white collar under that cape collar. When they went out they wore a veil. They spoke Italian. The parents were real pleased about that.

A few of the girls during my time in school, one of them was my cousin, went to the nuns' home convent in Chicago—the next step toward becoming a nun. I wanted to go too, but my father wouldn't hear of it.

Summer camp and other adventures
In summers, I would go to camp. A Scout leader came in and asked the nuns and priests if she could talk to us about going to camp. Wow! How fortunate we felt, that we could go to camp! We went to Camp Tichora in Green Lake. Boys went to Camp Wakanda on the northwest side of Lake Mendota, where Bishop's Bay is now.

At camp we had girls who cried every night. They did not like the food—they were accustomed to Italian food! They did not know anything about ham, or casseroles, or things like that. The counselors thought, well, best if they just went home.

But we loved it, my sister and I, most of us did. Camp was where I learned what ham was, and casseroles, and macaroni and cheese. We learned to swim, which was an accomplishment. And that is where I learned how to say "menstruate." We did not know what "menstruate" was. One older girl would go speak to the nurse. When she came back, she said, "Now girls, you call it 'men–stru–al.'" We would say "minstrel!" We wondered, "What in the world was that?" They called it "the curse," you know. We learned a lot of things at camp!

But we enjoyed it. We learned crafts, we used to make covered clothes hangers—you used that plastic string, gimp, it was called. Bracelets, too. And our parents would come to visit us, bring all kinds of goodies.

We went to the Worlds Fair in Chicago in 1933. We were surprised beyond belief that we were allowed to go, with an older girl as our sponsor. So we got on the train, and we asked for the menu, and we went to the dining car. They had BAKED APPLE! It was maybe 50¢. We could all afford to have lunch there in the dining car.

When we got to Chicago, we had no fear of being accosted or anything dangerous happening to us. It was just such a welcome thing, to be out in the world, Chicago! We visited each vendor, and brought home bracelets made out of little colored stones, little handkerchiefs, I don't recall where we had a meal there, but we must have eaten somewhere. We did not take a lunch, which is surprising.

25

On to high school

I started at Edgewood, for two years, and then my last two years were at West High, because my father thought that the Edgewood tuition was too steep. We could not talk the nuns into a scholarship. At West High, I wanted to take typing, but I had to speak with the teacher because of my missing finger. "Will I be able to type?" And bless her heart, she said, "You surely will." I give her credit for saying "yes, you can do it."

As far as careers, I wanted to be a nun, or else I wanted to be a nurse. My father would not hear of that. "Oh no, there are other professions where you don't have to use bedpans." He wanted me to learn to type. "Get in a business course, get in a business course." So that is why I learned typing, shorthand, all that.

The Greenbush neighborhood draws attention, good and bad

Neighborhood House was an important place to us. Two ladies from the South, Miss Braxton and Miss Griggs, started it. I think they were paid by the city, to help people out, who wanted to learn the English language, who wanted to learn to sew, or to cook. And they showed movies for entertainment. The girls, who belonged to small clubs, would perform. We would put on a production once a year.

That is how our parents learned to speak English, especially the women. The husbands didn't care, just so they understood what was going on. My parents both spoke English, I think, quite well. They were speaking an Albanian dialect at home. The Sicilians spoke Sicilian. And then there were the northern Italians who were from Lombardy. There was a group of them, and they mostly lived in the area across West Washington Avenue—Bedford and Main Streets.

The KKK was prominent then. They would come, crash a stone through a window or do something to your yard, just to frighten people. We knew it was the KKK, that they were against Catholics and African Americans. The African Americans were so wonderful then. They would welcome us to their houses, and we traded with them. One of the men had a barber shop, one had a hot tamale place, and someone else made barbeque. Nobody had any qualms about saying that they were our friends.

We had a very large picture window, and the KKK broke that window. You could hear them at night sometimes. They would burn crosses at Brittingham Park. That was really very scary.

Dating? Meeting Joe Bruno

My father was very, very overprotective, I think. For me it was fine, because I liked to be in the company of boys but I did not feel that I wanted to date. My sister did. She dated surreptitiously, but my mother would know where she would be.

Until I met Joe, formally, and his family, and he spoke his piece, I did not date. Then gradually, after I was married a while, I would hear "so-and-so had a crush on you," or "so-and-so was afraid to ask your father because he knew your father was very domineering." Some girls were allowed to date. But, mostly, it was surreptitious.

I knew Joe from around the neighborhood, of course. He would come by the house to go to the Y, or to Optimist meetings, and I would see him in church, and at school. Joe was very attractive, yes! I thought he was so wonderful. He was a couple of years older than me. He was a counselor, affiliated with the Optimist Club. Joe and I were both in plays put on by the YIP (Young Italian Players).

I had the lead with Joe in "Pierrot and Pierrette," and he decided he was going to cast his eyes on me. That is where I got to know him and felt myself falling in love.

We had met at the Columbus Day celebrations. At that time, they had parades around the Square, and went to Brittingham Park for the festivities. They were quite a thing! People would build floats. That was quite a project that everybody got involved in. And then they elected a King and Queen.

One Columbus Day, Joe sat close to where our picnic bench was. My mother was sitting there with some other lady, and he said, "I want your daughter." She was taken aback! She said, "You'll have to speak to her father!" That was Columbus Day, 1935. He asked my father, and we became engaged. I was 19. In June 1936, we were married.

My father approved of him, reluctantly at first. He wanted somebody who was making a lot of money, had a very good job. Joe was on a WPA project at Forest Products Lab, doing photography.

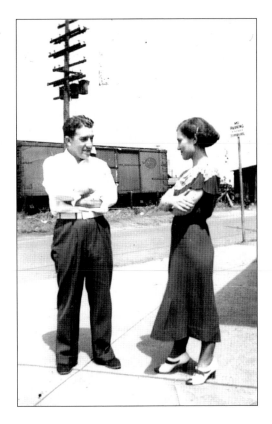

Anne is seen here with Joe when they were engaged. The photograph was taken in front of the family home on Regent Street, across from the railroad, in 1935. (Courtesy of Anne Bruno.)

Joe's father was killed by the Mafia, who were here from Chicago and from Milwaukee during Prohibition. He was trying to cover the back of this man who had a grocery store on West Washington Avenue, right behind Mr. Bruno's house on Milton Street. The Mafia had threatened him—they wanted him to either sell their booze, or buy sugar, that was a big factor, too. He did not want to buy from this outside element. Mr. Bruno said, "In case anybody comes through our yards, I'll just keep an eye out for you." One night, Mr. Bruno was coming home and was crossing through the yard, and the Mafia men came running around from out on the streets, and Mr. Bruno was killed on the front steps of his home. This was retaliation for protecting the store owner.

Joe's mother had an elderly mother living with her, and she had Joe and Sam, and she just panicked. She married this man, nice-looking, Dominic Puccio.

She married this man under false illusions, because he did not tell her about his kids. He had five children in an orphanage in St. Paul! She knew he had been married before, and the wife had died, but she was not aware of these children. So after he got married, then he wanted to bring all the children home. She was just inundated with relatives. "Where will I put them? Where will we sleep?" They had to go out and buy makeshift beds and mattresses. She baked bread three times a week. It was hard for Joe. But I must say, to this day, God rest his soul, he was so devoted to his mother, for putting up with this large family.

After she was married to Mr. Puccio, his son Jimmie had restaurants. He had Jimmie's Spaghetti House, which became Josie's (defunct since the fire). A lot of the women worked there, they cooked, my mother-in-law worked there.

Joe and I were married on June 6, 1936.

Reminiscing

When I was young, we got along with the Irish, we got along with the Germans, we got along with the African Americans. We did our homework together, walked to school together. There was no animosity. There was a real diversity. The boys did not have

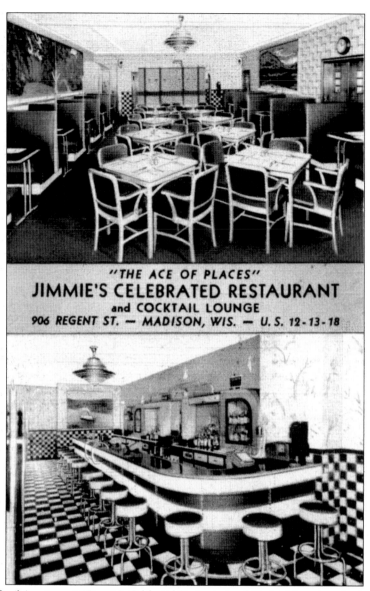

The Puccio family's restaurant: "Jimmie's Celebrated Restaurant and Cocktail Lounge—the Ace of Places." Joe Bruno's stepbrother ran this restaurant, where many of the family members worked. (Courtesy of Sarah White.)

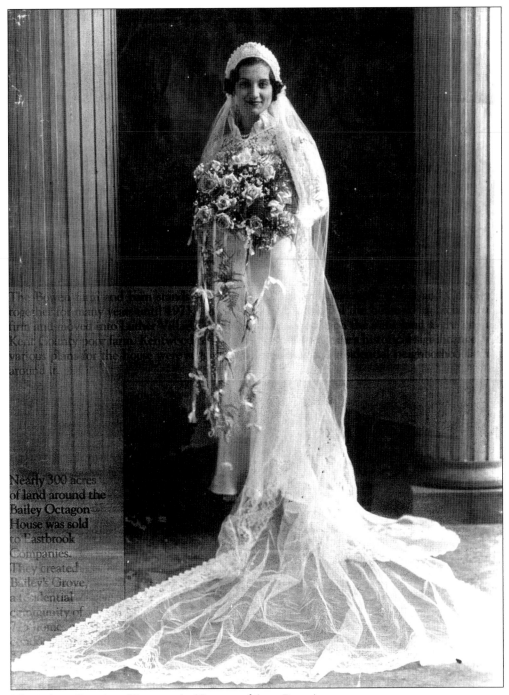

This is Anne Bruno's wedding portrait. (Courtesy of Anne Bruno.)

a meanness in them. If they had something against somebody, then it was my fist against yours. You would come home with a bloody nose, well alright, you are the winner. But otherwise, all the groups mixed well, which was really wonderful.

If someone needed help, you always gathered vegetables, or whatever, to help those who did not have much. Whenever I go someplace, I make a batch of biscotti or a batch of Italian cookies. Made with love.

I'm still involved in theater in a way, because of my son, who is a director. Last year, he put on "Sweet Canolli Nuptials." The cast was always looking forward, after each performance, that there were going to be lots of biscotti. I love baking and giving as gifts. It doubles my pleasure.

Anne Bruno has continued to give back to her community, volunteering at different times with Red Cross, Edgewood High School, St. Joseph's School and Church, and at Sequoya Library, and has held office in Catholic Foresters and Catholic Women's Club. She continues to be active with RSVP and the Westside Senior Coalition, and with her son's theatrical endeavors.

Anne and Joe Bruno lived in Madison with the exception of a seven-year period in Baltimore when Joe worked for the Social Security initiative, providing photographic services to document the process. Joe served in the U.S. Navy, and the couple enjoyed traveling to Navy reunions for many years after.

In 1975, Anne traveled to Sicily and greatly enjoyed meeting distant relatives living there.

Four

ROSEMARY MCDERMOTT, DOTY/WEST MAIN NEIGHBORHOOD

I am Rosemary McDermott, my maiden name is McGilligan, and I was born on June 21, 1925.

I grew up on West Main Street, in the 400 block, which in those days was called "the Bloody Fourth Ward." There were Irish, Germans, a lot of ethnic groups, a mix of houses and shops. There was a Chinese laundry, and an Italian shoemaker. The Sweets, a Jewish family, ran a grocery store on the corner. My parents, the McGilligans, were Irish, and ran an upholstery business right behind the house. It was a delightful neighborhood. At one time, streetcars ran up and down Main Street.

My mother had eight brothers and sisters, and they all stayed in the neighborhood! My mother was a homemaker, and helped in the upholstery shop. She took all the phone calls and did the bookkeeping.

The whole neighborhood would be very involved in elections. When there was

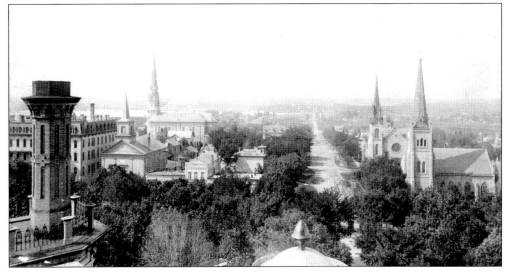

This photograph is the view from the Capitol dome toward West Washington Avenue and Rosemary's home. The four church steeples that can be identified are, from left to right, the First Baptist Church, St. Raphael Catholic Church, the First Congregational Church, and Grace Episcopal Church. The left foreground provides a close view of the decoration on a Capitol chimney. (Courtesy of Wisconsin Historical Society, WHi-8705.)

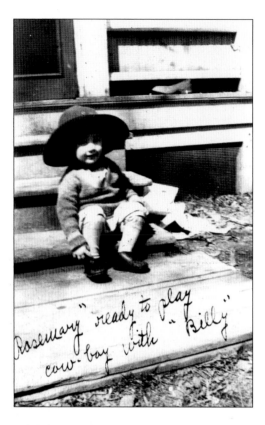

somebody running for alderman in the ward, everybody campaigned. My father always had friends running for office. If there was an election for mayor, or city councilman—anything in that realm—he would be there. My mother would always have a big pot of Irish stew going, in the kitchen, and my father would volunteer to drive anybody who could not get to the polling place. If you could not get there, he got you there, and got you home, so there was no excuse. When it was raining, he carried an umbrella to get you right inside. He had an old Dodge car and he would pile in as many people as he could. And if they hadn't had anything to eat, he would bring them back to the house and they would have homemade bread and a bowl of soup or stew. The Fourth Ward was mostly Democratic.

Our house was at the foot of what they called Main Street Hill. When you stepped out the door and looked toward the Square, the cross on top of St. Raphael's Catholic Church stood out and shadowed over the rest of the neighborhood.

Saint Raphael's Parochial School

The whole neighborhood went to St. Raphael's School. No matter what religion you were, you ended up at St. Raphael's. Then, after eighth grade, it split up between Central High School and Edgewood High School.

Dominican nuns taught us. The monsignor there knew every one of us, like he could read off the palm of his hand. There were 30 or 40 children taught by one nun in each room. The nuns knew discipline. And I think we had the fear of God in us—we certainly never crossed the nuns. They told us to do something, we never questioned it.

Punishment was a rap on the knuckles with a ruler. Not all of the nuns, but a few! I still have knuckles that remind me of that.

You started every day by going to Mass at 8:00. Then you stood outside the school, and they played a march on an old hand-wound Victrola, and you all marched in by grades.

Life under the shadow of St. Raphael's Cross

There were mostly boys in the neighborhood. I had two brothers, who also went to St.

Raphael's School and to Edgewood High School. I was the youngest. There was about seven years between me and my younger brother Bill, and about nine between me and the older, so I didn't play with my brothers, though Bill used to sell magazines and newspapers in the neighborhood, and I helped him deliver them. He sold enough subscriptions once to get a red wooden wagon, and he could put his magazines or newspapers in it and pull me with them while we delivered the magazines together. He was very good to me.

He always gave me money, a nickel or two. Right next door to my house was a little grocery store run by people from Switzerland. Their name was Stark. They made their own candy in the back of the store. Sometimes it was pretty stale, but if you got a piece of candy with a pink center it meant you got an extra piece free. And we used to eat and eat that candy, waiting for that pink center

to show up! They were delightful people. At that time, I thought, they were extremely elderly—probably they were 50 or 60 years old.

Next to the Starks was Leo Esser's butcher shop. Next to the butcher shop was Joe Fruth's barber shop.

One time, Joe Fruth told my father that his brother had a farm and if you wanted to buy a little piglet, they would raise them and when fall came they would butcher and you could have all the pork you wanted. My father asked my mother about it, and she thought that was a very good idea as it was hard to get good meat. They had done without it so much, during the war, so they thought this was a great idea, and he told Joe to go ahead and get him a pig. Spring went by and the summer went by and my mother said to my father, "Shouldn't those pigs be about big enough to be butchered by now?" "That's a good idea," he said, "I'll ask Joe when I go to get a haircut today." He

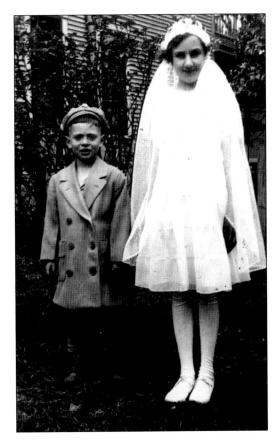

Rosemary's First Communion was in 1935. She is shown with neighbor Phil Dawling. (Courtesy of Rosemary McDermott.)

went down, and Joe was cutting somebody's hair, and my father asked, "Are they going to butcher our pigs pretty soon?" And Joe said, "Didn't I tell you? Your pig died!"

Well, how did he know whose pig died? We never did see any of that pork. It became a standard joke in our family, if something didn't work out right we would say, "Well, I guess your pig died!" We still use the expression, and my kids know the story so well. It just seems to cover everything in life.

Next came Scotty's Tavern. When work ended for the day, everybody used to stop in at Scotty's and discuss the day and have their beer. I used to try to deliver Liberty Magazine there, at the time of day I knew my father would be there, because he would always buy me a Coke. I thought that was really high living, to sit beside my father on a bar stool and have a Coke.

A strange thing I remember about growing up was Joyce's Funeral Parlor on West Washington Avenue. Everybody who died, from the Fourth Ward, was buried from Joyce's Funeral Parlor. And the wakes! We looked forward to going to the funerals because the wakes were so wonderful afterwards. You went back to somebody's house and there was a lot of friendship, and drinking, and food galore! With visitation at the funeral parlor, there were usually two nights. I was too young to be left alone so I went to all the wakes—and I could hardly wait for someone to die. Another party, that's the way I looked at it!

Fun around home

For fun at home, we played a lot of cards—casino, euchre, rummy, poker, bingo, and my mother would call the numbers. We played around a big oak dining table. Everybody had to be home by 8:00 in the summer. Our friends would come over right after supper, at 6:00, and the cards would be shuffled. Even some of the priests at St. Raphael's used to come down to our house to play cards.

At night, we would listen to all the radio broadcasts—they had stories. We would just sit and stare at the radio the way you do at the television, I don't know why. I remember Lux Radio Theater on Saturday nights. It was a two-hour program and it was a drama, with actors. The first time I saw on television someone

reading a script for a radio broadcast I was startled—I thought they memorized all that stuff, but they just stood there holding a script! When I first got my radio for my room, that was really living.

Sunday night, everybody sat around and we would have home-made ice cream. My father made what was called tutti-frutti. He would have a gallon crock in the basement and as each fruit would come into season, like blueberries, strawberries, he would put a cup of fruit in the crock, and a cup of brandy, and that would go on through the season. About Thanksgiving, my mother would make ice cream, and whoever was the oldest would go down. Finally I arrived where I was oldest and could go down and get a cup of fruit and bring it up and we would eat that on the ice cream. That was good stuff! All the fruit together, a cup of fruit and a cup of brandy. The fruit was very well preserved by the alcohol. And I found out the syrup was delicious, so when it was finally my turn to go down and get it I would take along a straw and sip up some of that juice, and that was really great, without the fruit. Then they found out what I was doing, and I think I lost my privileges for a while—I wasn't allowed to go get the fruit. We would ladle it over the ice cream or sometimes they'd put it over pound cake. The fruit never lost its color or shape. It was wonderful, really wonderful.

Bill Byrne's parents were my parents' best friends, so there were a lot of Saturdays and Sundays of what you call cookouts today. We would picnic in one yard or the other, but there was nothing cooked on the grill. The food had been cooked in the house—cold chicken, or ham, or roast beef—but we would eat in each other's backyards. We spent many a time between the two homes.

Swimming, sledding, and mischief in season

We played baseball a lot at Brittingham Park, just a few blocks away. We used to bike together a lot. We could go to Brittingham Park and bike the whole length of the park, or bike to Doty School and back.

We would go swimming in the summer at Doty Beach, which was maybe three or four blocks away, at the end of Broom Street. We could go for one hour in the morning, and one hour in the afternoon, and maybe

Rosemary's father is seen in the family's back yard on West Main Street, around 1937. (Courtesy of Rosemary McDermott.)

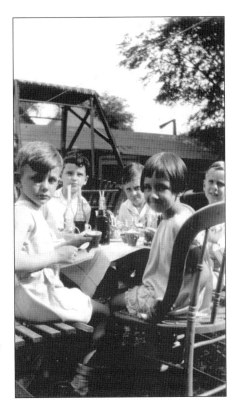

Seen here is a children's party. From left to right are Richard Springman, John Byrne, Donna Dawling, Rosemary, and Jimmie Dawling. Rosemary's friend Bill Byrne was present but not shown. (Courtesy of Rosemary McDermott.)

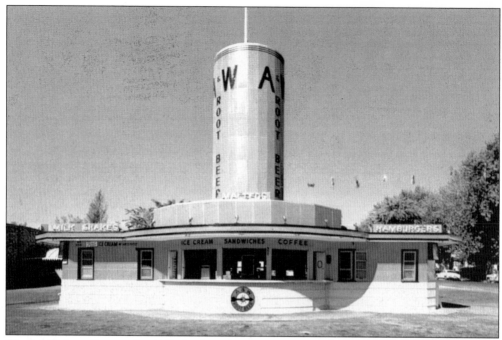

The A&W Root Beer stand at 900 South Park Street is seen here around 1950. A more modest A&W stand opened on that site in 1932. (Courtesy of Ann Waidelich.)

on a summer night the family would all walk down to the beach while we swam for an hour more. There was a lifeguard and he had a high stool that he sat on. He was always very handsome, all the girls fell in love with the lifeguard every year. He took very good care of us. And the lake, well, it was just like the lake today. Everybody got ear infections, but we dearly loved it. That was the highlight of the summer.

Sometimes my father would take all the kids in his old Dodge car and go over to South Park Street, where there was an A&W Root Beer stand. If the mother and father had root beer, all the kids in the car got root beer free in little mugs, half the size of the big ones, and you got to keep the little glass.

Halloween was never good in my life, as I was always in trouble. We had these wooden spools that thread came on. We would notch them all the way around, and wrap cord around it. You would hold it up against the window and you would pull the cord and it made a terrible sound against somebody's window. I always had a lot of really good cord because of our family's upholstery business, and the McNamara sisters

would be out chasing us with their brooms, because we had soaped their windows. I don't think "tricks or treats" was the thing at that time. We tipped over garbage cans. Anything to be in trouble on Halloween. The rest of the year I was pretty good.

The hills were high around our neighborhood. In the winter, on Doty Street Hill and Main Street Hill, we would get on our sleds and slide the whole way, across the intersection and to the middle of the next block.

When I got to be older, about 13 or 14, we were allowed to go around the square, and eventually down State Street. That got very exciting during the years when the Wisconsin football team would have a bonfire at the end of State Street for Homecoming. The students would gather and walk around the Square, against the traffic, causing all kinds of problems. They would end up on State Street and try to rush the two theaters, the Orpheum Theater and the Capitol Theater. They would get inside, and then the police would come with their tear gas and shoot it into the crowd, and that dispersed it quickly. I was right in the middle of the action, it seemed.

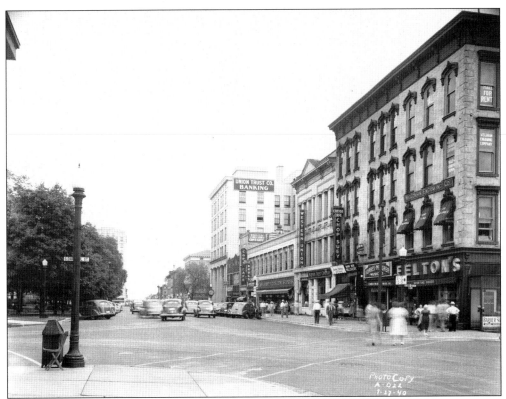

"Our corner of the Square," is seen here in 1940. This is the view of businesses located on West Main Street as seen from Carroll Street. These include Felton's, Forbes-Meagher Music, Fanny Farmer, Bandbox Millinery, Canton Restaurant, Home Savings, Western Union, F. W. Grand, Cop's Cafe, E. W. Parker Jewellers, Badger Candy Kitchen, and Union Trust. (Courtesy of Wisconsin Historical Society, WHi-6424.)

Shopping on the Capital Square

Right on the corner of West Main on the Capital Square was Felton's Sporting Goods Store. Forbes-Meagher Music Store was the next place. I played the piano, so I would go there to buy sheet music, or we would get records—the big old "78" records, which I have a collection of yet. They had listening booths. You could pick out a record and take it into a little booth like a phone booth and listen to it. It always came in a little jacket and you were careful not to break it, because then you had to buy it. Of course the personnel in the store knew all the kids from Main Street.

At that time it would be the music of the 1930s and 1940s, the big dance bands. We just loved that music. I was the only one of my set that had a record player, so my friends would buy records and they would all come to my house and we would sit on the porch and play our music. They thought I was very wealthy because I had that. I think my parents probably bought it because it was a good incentive to keep me home.

J.C. Penney had a big department store on the Square. Burdick and Murray was another huge department store. When you would spend some money there, a little basket would come down to the cashier and they would send the money up to the office. I would watch that money go way up on a little pulley and there would be a woman in an office that would make your change and back it would come, and I would count it again and again to make sure she did a good job.

Around the Square, there was a Woolworth's dime store, and further around there was the big Tenney Building, which housed a lot of doctors.

There was a store called Three Sisters that we liked to go to because they had the really

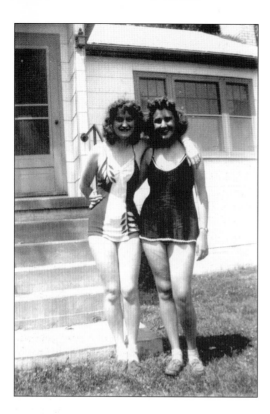

Rosemary (right) and friend are modeling their "really modern" bathing suits from the Three Sisters. (Courtesy of Rosemary McDermott.)

modern bathing suits. Once, we spent $25 each on a suit and our parents nearly killed us because that was a huge amount of money. Mine was red and white, and one-piece, and I thought it was just gorgeous. They were knit, of very stretchy material, I suppose wool. This was before polyester.

Barrons department store was across the Square, and Manchesters, were just wonderful stores. Barrons had a tearoom, which was really high fashion. We wore white gloves and hats when we went to tea there. This was when we were maybe 14 or 15 years old. A mother, or an aunt, or a grandmother would take you there. They would have little tea sandwiches and actual tea. We thought it was just wonderful! The food was excellent. That was really high fashion to us, to wear white gloves and a hat—you just felt really important. That was a highlight.

Mosley's Book Store was in the same block as Manchesters. My very first job at about 16 years old was working during the holidays at Mosley's Book Store. The first thing I had to do was wrap a globe. Well, I nearly quit the job then and there, because there was no way

I could wrap that in a decent-looking package. No box, and no matter where I put the paper it was never in the right spot. But I struggled, and stayed there, through Christmas vacation.

The Square was always alive with shoppers and couples just strolling.

"Edgewood gets in your blood"

Edgewood High School was a Catholic high school taught by Dominican nuns, and I went there from 1939 to 1943. Most of the group that I went to kindergarten and grade school with moved on to Edgewood. I can only say the best about it—wonderful memories.

This was far different from grade school! Freshman year, the people from St. Raphael's, the people from St. Patrick's, and St. Bernard's and Blessed Sacrament, were all segregated like we were in wards. You only hung with the people you knew from St. Raphael's. But then after the first year, everybody blended together, and become good friends.

Our generation wore saddle shoes, penny loafers, ankle socks, skirts, sweaters, and blouses. Because we went to Edgewood, your skirt had to cover your knees. If it looked like it didn't

the nuns would have you kneel down and if the skirt didn't touch the ground you had better lower the hem. By about junior year, the nuns didn't mind earrings and lipstick.

At Edgewood, the nuns had tea dances every Sunday afternoon. They did not serve tea, but a punch, and dainty cookies. The boys wore a suit coat and tie, and they were very uncomfortable and glad when the whole thing was over. Until of course, they got to be juniors and seniors, then it wasn't such a bad deal. There was prom coming up.

At my junior prom, one of the girls I had known from St. Raphael's was prom queen. That was exciting, because she was our prom queen, she came from our group. It was just like today, very formal, but the dresses were not quite so exposing as they are today. As long as you had your neck covered up the nuns didn't mind too much. I remember the long white gloves came up over the elbow, in fact. They didn't have wrist corsages like they do now. Gardenias were the corsages of the day. Of course, if you touched a petal and it turned brown you were just devastated.

Nobody stayed out all night. You went to dinner, and you had your dancing, and by midnight you were in. Usually the parents took you and brought you home. You met your escort and got your corsage at the dance. When senior ball came about, the boy could pick you up at your house and take you to the ball.

Marriage, work, or college? Wartime thwarts all plans

The nuns were wonderful teachers. Teaching was their life, and they were more than willing to share it with you. The one who taught me shorthand was known all over Madison. If you said she taught you, you didn't need any other recommendation—you had the job. She placed many of us before we even graduated. I think I graduated on Friday, and on Monday I started work at the Commonwealth Telephone Company.

I thought about going to college, but my mother had been a secretary, and insisted that was the only world there was and you did not need college. And my brothers took over the upholstery business when my father died in 1944, so college was not in their realm, either.

Others from Edgewood went on to college. We had a doctor from our class, and a couple of dentists, and several went into the priesthood, and some went to the University of Wisconsin, and on to law school. In fact, one of my best friends was Marigold Melli, Shire at that time, and she was one of the first women really accepted in law, and she ended up being dean of the law school, and very well respected.

I know exactly where I was when Pearl Harbor was attacked. My family had been invited to my brother's for dinner. He had just gotten married. They had the radio on, and Roosevelt came on and announced that Pearl Harbor had been attacked by the Japanese. I noticed that my parents were more distressed by it than I was—they were quite upset. Pearl Harbor really meant nothing to me at that point. It seemed like something very far away that really would have no effect on anybody.

As time went by, we became very patriotic, flying the flag, and making things to send to the servicemen overseas. I remember my mother making cookies and wrapping them for nephews.

The war was a big influence on everybody at that age because they were old enough to be drafted, or to volunteer to go in. They were going off to serve their country, very young and inexperienced. They were kids, you felt, there aren't words for it.

Madison really changed with the war. Of course gasoline was rationed, sugar, meat, and butter. Of course no one drove very much, because of gas rationing. You walked wherever you were going.

There were Army and Navy boys stationed in Madison. In fact, my husband was stationed with the Air Force in Madison, and I met him at a Rennebohm Drug Store.

We girls had practice for choir at St. Raphael's every Sunday afternoon, and we all sang in the junior choir. Afterwards we walked over to Rennebohm's on the Square and always had Cokes. Two of the soldiers were sitting having Cokes, too. We took ours to a booth, and they came over and asked if they could join us, and the next Sunday, I asked my future husband over for Sunday dinner with my family.

The Madison families really went out of their way to make the soldiers and sailors here feel very much at home. They would have them over for Sunday dinner and take the family car and

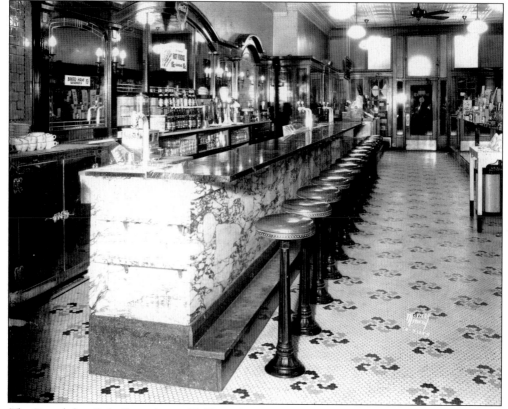

The Rennebohm Soda Fountain, at 13 West Main Street, is seen here around 1934. In a few years, Rosemary would meet her soldier, Mac, here. (Courtesy of Wisconsin Historical Society, WHi-16908.)

see that they got back to the field, because bus service wasn't that good at that time.

Up at the Badger Candy Kitchen, we would have wonderful chocolate sundaes, usually two or three of my friends. Of course, the soldiers would always have a friend they could bring for your friend. And then we would go back to our homes, we would put the records on, and we would sing and dance to our own type of music.

Later on Doty Street, they opened a USO club for the servicemen, where they would have live music and dancing on Saturday nights. It was right across from the old post office, downtown. That was a great gathering place for people to meet.

I have very fond memories of the war, in that respect. It brought a lot of handsome young boys around, and I think I knew them all.

My husband's name was Austin McDermott, but everyone called him Mac. His family was Irish Catholic, from Boston, but his father wasn't so sure about the Irish. He thought they fought too much, and they do.

My Mac was sent to the China-Burma-India theater of the war, and I became engaged to him when I was 19. He wrote every single day he was gone, and I suppose I did, too, or he wouldn't have kept writing. He bought the diamond in India, sent it to his sister, who mailed it to my father, who gave me my diamond!

I had not met any of his family. When Mac came back to Boston, they wanted me to come visit so I went by overnight train. That was in April 1945.

I just fell in love with his family. I hadn't seen him in three years, either. It was really a wartime romance. We were married in July 1945, at St. Raphael's Church. I was 20 years old. We were supposed to be married at 9:00 on Saturday morning, but Mr. Skelton passed

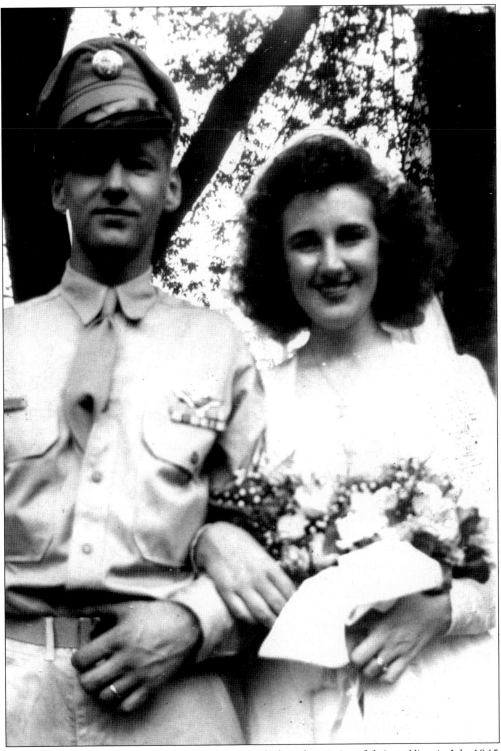

Rosemary and Austin "Mac" McDermott are photographed on the occasion of their wedding, in July 1945. (Courtesy of Rosemary McDermott.)

away, and they wanted the funeral at the time that our wedding was supposed to be.

The monsignor at St. Raphael's called to say, "I've moved your wedding to 8 a.m." Well, that was really early to be married, believe you me!

I always remember, shoes were hard to get at that time, so some that were at the wedding exchanged shoes at the back of the church so others could go to the funeral.

Rosemary McDermott raised two children, born in 1946 and 1953. The family traveled to Boston every year to visit Mac's family, the children enjoying the cross-country road trips.

Rosemary worked at Madison Newspapers in the national advertising department for 25 years. Her husband pursued a career with the Madison Board of Education. In later years, Rosemary worked for Meriter Hospital and for St. Patrick's Church until her husband's death in 1991. She now lives on Madison's near east side with the latest in a lifetime series of dogs.

Five

ANITA PARKS, DOWNTOWN/VILAS NEIGHBORHOOD

I am Anita Parks. My maiden name is Daitch. My mother and father came to the United States from a small town in Poland, Kobrin, somewhere near Warsaw, around 1920. My grandfather came earlier, I would say in maybe 1910.

I was born in 1926. My parents had married in Poland. In fact, my oldest sister was born there. She was six months old when they came over here. We were four girls, I'm the third. My grandfather Mazursky had a grocery store on the corner of Mifflin and Fairchild Streets, with apartments above, and a barber shop below. He also had a horse and wagon, and peddled fruit and groceries. I think my mother's family all settled in that building. My father's parents never made it here. All his relatives died in the Holocaust, so I never knew any of them.

My parents were such new immigrants that I don't think English was my first language. I'm sure that my parents and my grandparents spoke Yiddish. I learned whatever English I knew from babysitters.

The first home that I remember living in was on the corner of Chandler Street and West Washington Avenue. Before long, we moved to Orchard Street, not far from Vilas Park. Our family was very close with our relatives, who all lived within walking distance. My sisters and I would babysit some of the younger ones, and our families would get together for parties, and maybe eat at one another's houses on Friday nights. We always had Passover seders together, sometimes back on Mifflin Street at

my grandparents' house, and sometimes at my aunt's, the Rosenbergs, who lived not far away. The neighborhood didn't spread out because everyone wanted to be within walking distance of the synagogue—you are not allowed to drive on the Sabbath. That is why people always lived near the synagogue, so you could walk.

Here is how important the Passover Sabbath was. My grandmother, who lived on Mifflin, downtown, would never drive or ride on the Sabbath. But this particular Friday night, the family was all gathered at our house. She loved being with the family so much, but it was during the war, and she lived downtown. So she walked a block up to State Street. The bus came and she asked a soldier if he would put the money in the meter. She got on the bus, and all of a sudden it is Friday night, and we see Grandma coming—we were just so shocked. She said, "Everybody's here. I want to be here. That's what I had to do to get here."

After-school religious study and other pastimes

My mother's family was very religious. My uncles were all presidents of the synagogue at one time or another. My grandfather was one of the founders of the first synagogue in Madison, called Agudas Achim, at Park and Mound Streets. (It is now called Temple Beth Israel.)

We went to afternoon religious school every day after regular school at Longfellow Elementary. We learned Hebrew, learned how to read the Bible, that sort of thing. There were

eight or ten kids at the most. I can't say that I was thrilled to do it, but in some ways it was fun. It was harder on the boys—they wanted to be out playing ball.

I have no memory of playing after school, or of having any toys. I know I never had a doll.

Radio was a very big thing in those days. I remember being absolutely addicted to a radio program called *One Man's Family*. It took place in San Francisco, and I think I learned what the non-Jewish American cultured people were like from that program. It opened my world to a different lifestyle, a different group of people. It was absolutely fascinating for me to learn how other families lived.

At our house, the family gathered around the radio and we would listen to Eddie Cantor. I had the cutest grandmother in the entire world. My mother's mother was just a little thing. Because she was little and the radios were tall, she would pull up a stool and sit by the radio and listen to the broadcast.

As we got older, in high school, we got a portable record player. I remember teaching my cousins and some of the boys we knew how to dance. We would roll up the carpeting in the living room.

The Depression was very hard

We were very much aware of the Depression. I can remember men coming to ask for food at our back door. My mother gave them sandwiches. My mother made our clothing. Although she was pretty good at it, I hated that. My idea of heaven was to buy a ready-made dress at Jack and Jill's, on State Street, for $3.98. Then, that would be expensive.

From the time I was 12 we had Dolly—she was like a member of the family. She was mentally handicapped and came to us from a state hospital. A state social worker brought Dolly to meet my father. "Mr. Daitch, your wife has four little girls, wouldn't you be able to take in Dolly and she could help your wife with the children?" Dolly became like the fifth girl in our family. We came to have a relationship with her family. They were very happy that she had a place to live.

Young girls from the country would come live with us, and we adored them. These were

farm girls who wanted to live in town. They were not Jewish. We kept kosher, so they learned how to keep kosher. I never learned to cook. I don't remember doing much housework, because we always had the farm girls, who would be babysitter and maid. I do remember washing the floors sometimes in the kitchen and chores like that.

From time to time, we had to take in roomers, to make ends meet. We were in a two-story house with four bedrooms. At one time we took in a cousin, a young man, who managed to get out of Europe before the war. Another time, a cousin who had become orphaned came up from the South. She came here to go to the university, and she stayed with us for a while. That was the happiest time of my childhood. I was maybe eight. She was amazing! Her name was Ann Weinstein. She came from a small town, Jasper, Alabama. She changed our names, every single one of us. My name originally was Anna, she changed it to Anita. My sister Helen's name was Alta, Rosalind was Rosie, and Gerry was Goldie, like Golda. She said these are not American names and the girls should have American names. She was a firecracker!

My father's world: the army surplus store

At first, my father had a small haberdashery on the Square with a partner. Then he opened an army surplus store on East Washington Avenue. I think maybe my uncles loaned him a little money so he could stay in business. That was maybe 1933. The army surplus goods were what was available after World War I. We had a lot of army blankets in the store, army uniforms, army coats. In the Depression it was a way to get inexpensive, good material, warm things.

Frank Lloyd Wright and the men in his school used to trade at my father's store. My father sold them shoes and boots and jodhpurs. If you ever see pictures of them they were always wearing jodhpurs. Never paid their bills. It occurred to me how sophisticated my father must have been to realize that this was a great man, and so he never pushed it.

The clientele at my father's store were mostly farmers, and people who wore uniforms, like gas station attendants. Even though we were girls, from the time we were 12 years old, we all had to start working at the store. I hated it. It had absolutely nothing to do with being paid. This was like family chores. That is what you did.

Growing up Jewish in the time of the Nazis

Growing up with what was going on in Europe, it was the focus of our life. There were itinerant rabbis who would come through town, who had escaped from Europe, or who had heard from Europe. They came to the synagogue to tell us what was happening.

The Jewish community was so fresh here, everybody an immigrant, just finding their way. They didn't realize if they had any power, what power they had. And another thing, we were terrified because we could see what anti-Semitism was doing in Europe, and we were very sensitive to anti-Semitism here. There was a Father Coughlin who had a radio program, from Detroit, who was terribly anti-Semitic.

Don't forget, my parents were from Europe; the pogroms were why they came here. Even before World War II, we already were Zionists.

My mother used to tell the story that her father gave her gold earrings for her 12th birthday. People would come around to their small town and talk about going to Palestine. The Zionist movement started in Europe, the idea that we have to go where we will be safe. My mother remembers people coming through and talking about "we have to raise money to buy land in Palestine, so we can settle there. We can be farmers there, we can till the land." She remembers giving her gold earrings to this cause.

The refugees, those who survived the concentration camps, started coming here. Every town in the country that had any Jewish community would try and take in refugees. My father sponsored several people who were able to get out. Those days, you could not even find an apartment for yourself, and it was hard finding places for them to live.

I have come to realize that what people feared most was refugees—the thought of being overwhelmed by them. When the war came and then the refugees, if you were a Jew worth anything, if you weren't an idiot, you just knew that this was the most important thing in your life. You had to build up Palestine so that the Jews had safety. The name Israel had not come into our vocabulary yet.

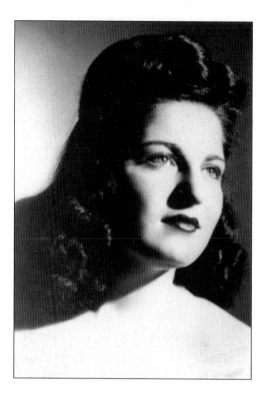

This was the focus of my life, how could it not be? If you were Jewish and you knew what happened. To this day we are very much attuned to what is going on in Israel.

Meeting the man I would marry

Because my father carried military clothing, and was able to supply the soldiers, the war was the only time my father ever had money. It was just a coincidence, that his store should be on the route where the soldiers came uptown from Truax Field, right there on East Washington Avenue. Working at the store, we met a lot of soldiers.

One day, a young man came into my father's store with a letter of introduction from one of the salesmen who sold clothing to my father and also sold clothing to the young man's father in Milwaukee. This young man, Bill Merkhow, was coming here to school, and his parents wanted him to know some Jewish people in Madison. My dad invited him to dinner. My sister Rosalind was very beautiful at that age, and he took a fancy to her.

Then the next year, his cousin Hy came with him, and he turned out to be my husband. I was 14 at the time. They were both premed at the university, five years older than me. Up until their class at the medical school, there was a quota for Jewish medical students. That is hard to believe now. Hy and Bill were roommates on Kendall Avenue with a family by the name of Sinaiko, an old Jewish family in Madison.

I will never forget the first time I saw Hy. I was sitting on my bike in front of the house when they pulled up, and I fell into the sticker bushes. My father gave him a job, which he desperately needed. I actually could not stand him at first. I had other boyfriends in my teens. I didn't really start going with Hy until I was 17. On dates, he never had any money to do anything. He only had one suit and if it was in the cleaners, we couldn't go out on Saturday night.

We were married in 1945, when I was 19, at the Loraine Hotel. I had to make the food myself. I remember having to practically bribe the butcher so that we could have a turkey for turkey sandwiches. During the war, it was hard to get any meat. I had to invite the purveyors to the wedding in order to get enough food. I never dressed as a bride. I had my first and probably only suit for five or 10 years, an aqua suit, and I had a little hat made with flowers.

Anita's engagement portrait is seen here, taken in 1944. (Courtesy of Anita Parks.)

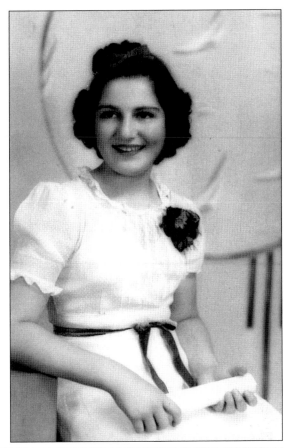

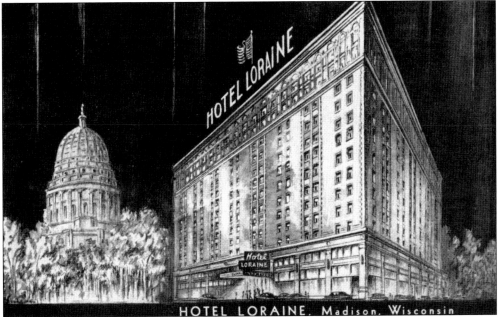

This postcard shows the Loraine Hotel, where Anita and Hy were married in 1945. (Courtesy of Sarah White.)

At first, we lived with my mother and dad. My younger sister was still at home. During the war, you could not find a place to live, or a car. So we lived with them, and my oldest daughter was born when we lived at that house—we lived there for the first 10 years of our marriage.

I was so inspired by women in the community!

While we were in high school, my sisters and I were encouraged to go to college, and we all went. I started out thinking I would be a medical technician. I thought that sounded like a great thing to be. I think I switched majors every semester in my college career. When I took psychology, I thought that was so wonderful. When I took sociology, I thought that would be a good career. But I got married before I finished school.

I was so inspired by the women in the community! One, her name was Fanny Mack, she was one of the founders of the Madison Hadassah chapter. (Hadassah is the American women's Zionist organization.) Fanny Mack was also one of the founders of the Madison Women's Club. She was highly intelligent, an educated woman. Besides Fanny Mack, I was inspired by Rachel Szold Jastrow.

Rachel Jastrow was amazing. Her husband was the first Jewish professor at the university. She was liaison to the state legislature for the Women's Suffrage Movement at the time when it was the first state legislature to ratify the vote for women. She also was one of the founders of Madison General Hospital.

Rachel Jastrow's sister was Henrietta Szold who founded the first chapter anywhere of Hadassah, in New York, in 1912. In 1914, Henrietta came to Madison to visit Rachel, and they started the second chapter in the whole United States here. I knew every single one of the women who were the founders of Hadassah here.

I remember how thrilled I was that I was asked to join the Women's Club. It was right after I got married.

It is important that people remember Rachel Jastrow and the Zionist movement, the connection to Madison, how much it means to the Jewish community here!

I have had a wonderful life. Madison has changed, but I always see it as having changed for the better.

Anita Parks's husband served in the Army in World War II and was recalled to the Korean War mere days after the young Parks family finally moved into a home of their own. He built a medical practice in Madison and the couple raised two daughters and one son, all of whom became doctors and carried on the family's enthusiasm for Zionism. Anita Parks has visited Israel eight times, and all the children have traveled there.

Six

DONNA FISKER, UNIVERSITY HEIGHTS NEIGHBORHOOD

I am Donna Lappley. Fisker is my husband's surname. I was born May 8, 1928, at Madison General Hospital. My mother's family were all shocked, because they had home births. She was trying to be very avant-garde.

When I was growing up, we lived at 2025 University Avenue, about four blocks past Breeze Terrace, west of the First Congregational Church. Madison at that time did not go past Farley Avenue.

I am an only child, one of the few only children back then.

Local German and Irish roots combine

My father's family was German. My grandfather and his brother had a lumber company out in the little village of Fitchburg. My grandmother actually came babe-in-arms with her parents from Germany, in the 1870s. She was the real boss of the family! Little bitty lady, not five feet tall, but ruled with an iron fist.

My mother's family was German-Irish, a farm family from Waunakee. The German and Irish families intermarried, after they got over being stand-offish to each other. My Irish grandma was a graduate of the Academy of St. Mary's in Madison, and had been a teacher. She sent her oldest daughter to that academy, which is now Edgewood. She earned that money peddling eggs and butter and chickens to Big Bug Hill.

That farm still exists, outside Waunakee. I think of the house often, with its summer kitchen. When I am here with my air conditioning, I think of her out cooking in the summer kitchen. And her extensive canning!

We spent time at both grandparents' homes every week, that was a part of my childhood I liked very much. The cousins would be there, almost like brothers and sisters.

My parents did not have much money. We would not go out to eat at restaurants much, but I can remember going out toward Mazomanie where there were farm women who served dinners for less than $1 per person, family style, with fried chicken, mashed potatoes, green beans, cabbage salad, all placed on the table in big dishes. And always pie.

Young eyes take in the deepening Depression and impending war

My father and his brother were in a storage garage business on Webster Avenue when I was born. A businessman would drive downtown to work, park in their garage, then walk or be driven to his business. This business was very successful, and very profitable, briefly—and then suddenly the crash. The Depression came just about the time I was born.

After my dad's business folded, he became a civil service employee in the Sheriff's department. At that time, the salary was infinitesimal. My mother started taking roomers, so they would not lose the house. She rented tourist rooms, which was common at that time, around 1935 or so. We slept on the first floor. We had day-beds that would open out, that had to be closed up again in

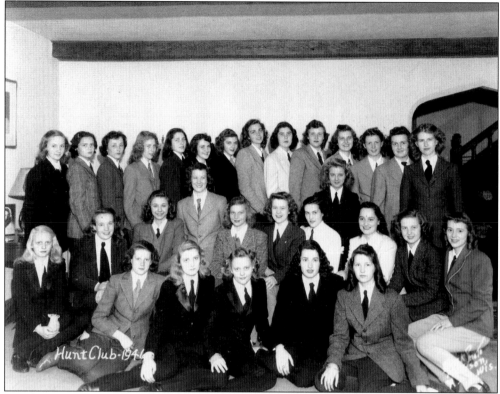

Seen here is a group portrait of the Hunt Club, in 1946. Donna is standing third from left in the back row. (Courtesy of Donna Fisker.)

the daytime. This seemed normal. Money was scarce for everyone up and down the street. But everybody was in it together; there wasn't anybody living extravagantly.

In the neighborhood, I was a tomboy. At school I was a mouse! I was one of those who sat and never said anything unless called on. Then I would blush beet red, because I was the focus of attention and unsure of myself.

In about 1937 or 1938, I had a fifth grade teacher who was Jewish. She knew what was really going on in Europe. This woman must have had family there. She would go on by the hour, about these awful things that were happening. As fifth graders, we did not know how to deal with it. I felt oppressed by her seriousness, but it was totally a mystery to us, what this woman was talking about.

Fun in school and out

In about 1940, I started junior high, which at that time was in the same building with West High. I was a middling student, but I had lots of fun. I was very active in athletics for girls. My friends and I were very involved in going to all the sports events, like football, basketball, and track. In the summers, the playgrounds had all kinds of programs for girls, like baseball—which I was not good at, but my friends dragged me into it anyway.

Then there was the Hunt Club. This was a group of girls who were all equestrians. We were in the holiday parades. We had to ride the horses downtown and then ride them back to the stables after the parade.

In high school, we girls had potluck groups, very selective. And then there were sororities. I belonged to Sub-Deb, which had students from Central and East High Schools. It was a wonderful opportunity to finally get beyond my West High world.

At that time, I often went fishing with my parents, up at Clam Lake. People now travel to far places, but to my parents renting a cabin in

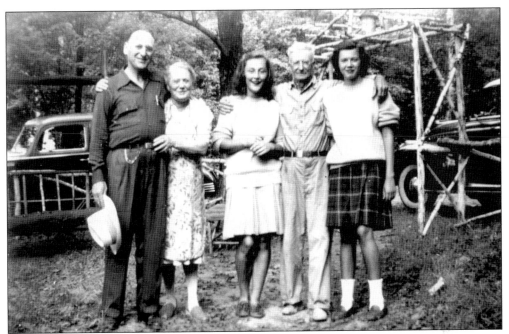

Donna's family is seen at a cabin they often rented near Hayward. From left to right, they are Donna's father, Hansie (the owner's wife, a Russian émigré), Donna, George (Hansie's husband), and a friend. Hansie would cook exotic dishes for the family, which they attempted to like because Hansie was so gracious. (Courtesy of Donna Fisker.)

A group is photographed on a fishing trip to the Chippewa Flowage. From left to right are Donna's father, Donna, her mother, and her mother's brother-in-law John Dart. The family would often go on trips that included Donna's aunt and uncle. (Courtesy of Donna Fisker.)

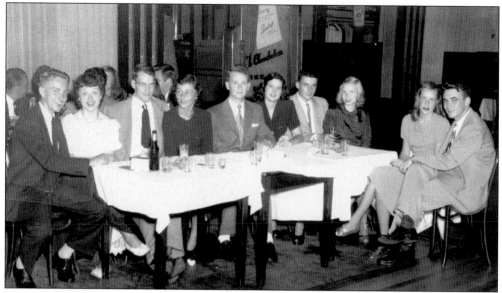

Donna is seen with a group of friends, out dancing at the Chanticleer. Donna is seated fourth from left. (Courtesy of Donna Fisker.)

the north was recreation. Sometimes I would bring a friend, or my aunt and uncle would come with us. The old tradition of doing things with extended family as your social group, that is something that has gone.

Dancing and dating

I had several boyfriends. My set of friends always had a date on Saturday night. We would go out to ballrooms, dance halls, or to a movie. There were public dances everywhere. The Chanticleer was a restaurant, bar, and ballroom out in Middleton. Frenchy's was out on University Avenue. And then there was the Hollywood, in Monona. On the east side, there was the Spanish Village on Commercial Avenue near Oscar Mayer. Tiny dance floor, but always had a wonderful band.

We dated fellows who were a year or two older, who had cars and could drive to these places. No one drank to excess. I don't remember anyone ever being drunk—we went to dance! All of the wonderful music, Artie Shaw, all of the Big Band, that was our era. I had a lot of records.

Graduating from high school, charting a course in life

I graduated high school in 1946. By that

time we had been in the war since 1941; gasoline rationing, walking everywhere. There were soldiers in town, you would see them everywhere. They marched to class, in groups of 20, with their battalion flags. The Army radio school was housed in an old auto garage right down from our house. My husband-to-be trained there. There was a community center downtown, the USO, but most parents were pretty strict about girls going out with soldiers.

Because my friends had all chosen the college track at West High, I did too, but I didn't have a "destiny." It was one day at a time, not the long view, for me.

I had role models, especially my dad's three sisters. Each had a professional career. One was in the medical technician program at the university. She went on to work at University Hospital, respected in her field. Her sister went for a master's degree at the university in biology. She went to the west coast, taught science in a Lutheran college, and became the dean of women. And the third sister owned and ran a boarding house.

My mother's sisters were probably more limited in their goals or expectations, because the women who did not marry became caretakers in the family. But I don't deprecate

Seen here is Donna's high school graduation in 1946. Donna is on the right, her friend Marilyn Turner Jones is on the left. (Courtesy of Donna Fisker.)

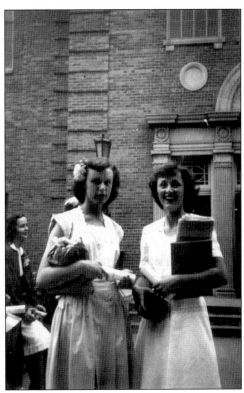

This is Donna's college graduation portrait. (Courtesy of Donna Fisker.)

that. They did a fabulous job, doing what we now pay other people to do.

In a way, the Depression gave women opportunity. You could find small jobs as a secretary or clerk or in a restaurant, something to offset expenses, but you could not find a place to really enter a career. So some women went to college, when they could not find proper work.

I went to college here, as well. I never moved out of my parents' home until I married. And that was not unusual. I was 25 when we were married in 1953.

"We've seen the best of Madison"

I think Madison was more egalitarian when I was growing up here.

Maybe I was totally naïve. I went to high school with the university professors' kids, and with kids from Maple Bluff, and it didn't bowl me over to visit where they lived. The homes were not forbidding. They were different, but they were not exclusive.

At the other end, my dad did a lot of visitation as part of his VFW activities. He would often take me along, so I visited the homes of some of the men from World War I, who had been disabled, and were living frugally. There was not a class distinction.

When I was growing up, you never felt that you could not go somewhere because of the money. The first playgroup, the Madison Theater Group, performed around town, in the high schools. The ticket fees were modest. You could afford to go to the musicals, or theater, or even operas. But recently, I think we are getting very glitzy.

Anyone of any age probably thinks they have seen the best. But I do think we saw the best of Madison. Not because of the Depression, but our inheritance with that experience. There was a time when people had such rich lives that they did not have to have money to feel rich.

Donna Fisker and her husband Harry raised two children, and later enjoyed traveling together. Donna worked in publishing, including stints at Madison newspapers, *Wisconsin Trails* magazine, and the University Press. She and her husband continue to live on Madison's west side, not far from where she grew up. Donna stays busy with volunteering and her own role as a family caretaker. "I never realized how strongly that thread of always having family around was for me."

Seven

JACKIE MACKESEY, CAPITAL NEIGHBORHOOD

Jacqueline is my first name, and my last name back then was Gregory. My father, Russell Gregory, was from Tecumseh, Nebraska, and my mother Dolly was from Sonora, Texas. They both came here to work at Mendota State Hospital.

I think those young people were filled with the pioneer spirit. My mother wanted to live in Austin, Texas. When they came to Madison to work, the city reminded her of Austin, and she fell in love with it. Mother said, "I'm staying right here." I was born in Madison in 1930.

Work demands family adjustments

As attendants at Mendota Hospital, my father and mother could live there, but they had only one room. They were not permitted to have children at Mendota. They knew a Mr. and Mrs. Haddon who once lived and worked there. Mrs. Haddon supplemented their income by taking care of children at their home on Helena Street. My mother knew Mrs. Haddon's would be a safe, loving home for me. Each week, my mother and father would pick me up for their one day off, and I was with Mrs. Haddon the other six days.

That was why my mother divorced my father—he was content to have a situation like that. She needed more of a home, and he was not going to provide it. My mother was

Jackie is seen with her mother, Dolly, around 1932. (Courtesy of Jackie Mackesey.)

55

21 when I was born, my father was 24. They divorced in 1931 or 1932.

I assume it was pretty soon after the divorce that she remarried. I do not know how my mother would have survived otherwise. My stepfather was Hugh Elver, a wonderful man. My half brother, David, was born when I was 10. He is my only sibling.

I spent holidays and summers with my father in Chicago. I took the train to Chicago and back alone from the age of four or five. I would have a note pinned to my clothing with my name and address and my dad's name to show who was picking me up, and I was put in the conductor's care. The trains were so elegant in the 1930s. I would sit in the dining room at a table with white tablecloths, and the waiters would serve me. It was great fun, and something that most other kids did not do. I never saw other children traveling alone.

During the rest of the year, I lived with my mother and Hugh Elver.

Hard work for adults, chores for children

When I was little, my mother worked at the Loraine Hotel, in the laundry, pressing shirts.

Hugh Elver, or Hughie as I called him, was a cab driver. Before the war he had to make $5 a day in order to pay our living expenses. He could never come home until he made $5; sometimes that took 12 hours or more.

My mother took in boarders all the time. After my brother was born, we had a housekeeper, mainly to take care of him. Ours were farm girls usually, who wanted to live in Madison, and came to the Beauty School. While they attended school, we gave them room and board, in exchange for helping in our home.

My mother made me "toe the mark." I had to dust and polish the bottom of everything—all the chairs, under the dining room table, under the buffet, under everything. We had the cleanest bottoms of furniture in our house. I would have a list of tasks to do during the day when my mother was gone. That was partly because she wanted these chores done, but partly because "idle hands are the devil's work." And I could so easily have been un-idled with pleasanter things! I had to fight to find time to read. Reading was something that you only did when everything else was done.

We used to get our clothes damp dried, because we did not have a washing machine. The laundry service would pick up the dirty clothes and bring them back in the basket, washed and damp. I would hang those clothes on a clothes line out the kitchen window. In those days you ironed your sheets, you ironed everything. I did not see any reason for ironing all that stuff. My mother had quite a chore on her hands with me! They were hard working people, and they always wanted me to work, too.

Downtown neighborhoods and pastimes

We lived on South Webster Street near the Majestic Theater. A store was on the first floor and I was not to pester the owner. The people who owned the building had an apartment on the second floor, and the third floor was where we lived. There were windows in the front and back of the flat. We had one sky light.

There was a gas station across the street. We did not have a telephone in our house, so I would use the phone there. He did not charge, I just asked and he never refused. I made calls for my mother, mostly, to Hughie's dispatcher. He could get in touch with Hugh and tell him "your wife is looking for you."

We ate in restaurants often, something that most families did not do in those days. That is probably the phone call I made, "Hey, when you go to supper we'll go with you." My mother was a good cook, and we had wonderful dinners at home, but she did not like to cook every day, so we used to go to Kelly's Restaurant, on West Washington Avenue, or greasy spoons on Williamson Street.

Have you heard the expression "cut the Capitol?" When I was a kid we used the Capitol as a short cut, rather than walk around the Square. One of us would say, "I'll meet you at Coney Island on State Street," and then we'd say, "Well, how are you going to walk? Are you going to cut the Capitol or walk around it?" We knew that building was beautiful.

If I wasn't in Chicago with my dad, my summer days were mostly spent trying to figure out how I could go to the Majestic Theater. I loved movies. From my living room window I could see the marquee; I could see when the movies changed.

I did not get an allowance and I needed 12¢ to go to the movie. My girlfriend Joyce Hegg

56

Jackie's mother and Hughie are seen outside Kelly's Restaurant. Kelly's was across from the Washington Hotel on West Washington Street. Dolly's first waitress job at Kelly's led to big ambitions. (Courtesy of Jackie Mackesey.)

and I would make lemonade. Between her house and mine we could get lemons, sugar, water, and ice. Our counter was a cardboard box. We would pick a corner on Main Street. Our lemonade would be 1¢ or 2¢. We would have to earn 24¢ for both of us to go to the movie. It would take all day to get 12 or more people to buy our lemonade. Those pennies were valuable to them, too.

At the movies, we mostly saw Westerns. I loved Shirley Temple movies. They did not have many kid's movies until Walt Disney.

An impressive movie for me was *The Wizard of Oz*. I saw it in Chicago before I got on the train to come back to Madison. I loved Chicago, and wanted to stay longer. I cried all the way back to Madison. I would click my heels and wish, but it never took me back. I treasured visits with my dad, because we were two free spirits.

My stepfather was really good to me. I always think what a difficult person I was to live with, because he wanted to adopt me. He really wanted a whole family, but I was very loyal to my father.

A typical school day, a typical weekend

I was in the first class to go to Lapham School when it was brand new. My mother always had my clothes laid out on a chair for me to put on each morning. I had three dresses for school, and I would have to wear each one twice before laundering. I would get up and dress, brush my teeth, wash my face, eat a little oatmeal, and leave for school. Then my mother went to work.

I would walk a mile to school, picking up one or two friends on the way. There was not a hot lunch program. I would have to walk home a mile and walk back a mile after lunch. I would walk home again at night. I was pretty skinny because I walked four miles every day.

Sometimes I would go over to play at one of my girlfriend's houses. It was rare for them to come over to my house as no one was home. We played with cut-outs. We dressed our paper dolls in clothes that we made. We had plenty of crayons and paper and scissors, and boxes of cut-outs. I don't think we had boy dolls, only girl paper dolls.

And then the weekend would come and I would go to Mrs. Haddon's—not every weekend, but often. Mrs. Haddon was a good Christian. She would go to church twice a day on Sunday. We went to the Tabernacle on Atwood Avenue (which is now a community

center) in the morning, and then at night we went to another little church, behind the Eastwood Theater (the Barrymore now).

I was saved in that church many times. They would have missionaries come in, I always got saved when the missionaries came. There was music and singing, and missionaries speaking about the perils of the jungle, the places that they had been. I would always have something along, in case I was not interested, so I could color or I could read.

Mrs. Haddon had the patience of a saint. She had a deep concern for children and people with special needs. We were always visiting them. I had a close bond with Mrs. Haddon and visited her often.

If I didn't go to Mrs. Haddon's, I might go for a drive with my family. Fishing was big with my mother and Hughie. We would drive down to the Wisconsin River, I would play on the sandbars, and they would fish. Because Hughie was a cab driver, we always had a car. Families went for Sunday afternoon drives if they had any way of doing this.

Entertainment during those years was bowling, fishing, playing cards, or Sunday drives. My mother and stepdad were great bowlers. Bowling scores were in the newspaper every week if you were good, and they were very good. They used to bowl in tournaments.

Central High

I started in seventh grade at Central High in 1943. I found it very exciting. You went from classroom to classroom, always rushing to the next class. We had lockers with combination locks, and I had nightmares each summer worrying about forgetting the combination. I don't know why I didn't write it someplace safe, but I never did.

In junior high, we had the basic classes; history, English, and algebra. We had gym class. I had to suit up for gym. The big fear was that the fire alarm would ring while we were in the showers or in our gym suits.

I was a student council representative, I was one of the delegates for my homeroom. I was in the band. I wanted to play the drums, but the band director Mr. Klose wanted me to play the flute. He won out. I played flute 7th through 12th grades. Central High had a marching band. We didn't have an athletic field

Seen here is the Central High Marching Band as shown in Jackie's 1948 yearbook. Jackie served as corporal and secretary of the band that year. (Courtesy of Jackie Mackesey.)

Jacqueline L. Gregory's 1948 senior yearbook portrait was accompanied by this poem: "Radiant hair, a lovely smile, here's a miss who's right in style." (Courtesy of Jackie Mackesey.)

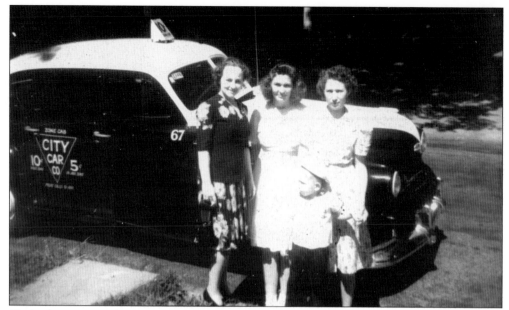

Hugh Elver's City Cab is seen here, from left to right are Mrs. Haddon's daughter; Jackie; Jackie's young half-brother; and Jackie's mother, Dolly. The photograph was taken around 1942. (Courtesy of Jackie Mackesey.)

to practice on, so we practiced formations at James Madison Park. We marched through the streets of downtown Madison. It was great fun.

I was an usherette. We monitored the auditorium doors to make sure everyone was orderly coming in and out, when the principal called an assembly. I think band, student council, and usherettes were my main extra curricular activities. I was an officer because I was secretary of band.

We used to go to Coney Island on State Street after school. There were booths down the center of the restaurant, and booths along the wall. Waitresses greeted you with a glass of water without asking for it. And you did not tip, at least we did not. They had hot dogs, Cokes, and ice cream. I don't remember ordering french fries. Our Cokes came out of a fountain and were 5¢, and they could be flavored. My favorite was cherry Coke.

We would go to the Loft, a place for teenagers, one block off the Square near King Street. There were lounge areas, to sit around and talk, and play games, very casual.

There were dances every weekend. Some of the girls could really jitterbug! There were some very fancy dancers. Rita Moran was one of the best. We wore nice gabardine slacks,

and broomstick skirts. The slacks were belted, zipped on the side, man-tailored, a Katherine Hepburn look.

We wore makeup starting about ninth grade. Most of us went to school, put on lipstick, and took it off before we went home. I never had nylon stockings because the war was on. We wore leg makeup. We even had a little pencil to put the seam up the back of our legs. If it was warm the makeup would melt and get all over your clothes. Simpsons received the first shipment of nylons after the war. The women were standing in line three blocks out. You could buy just one pair. I was so excited—my first pair of nylons.

First jobs and dates

I got my first job and the only one I was ever fired from when I was 14, that would be 1944. I worked at Savidusky's dry cleaning plant, pressing coats and belts. I could not tell the difference between plastic and leather belts. I ruined quite a few belts with the press. But I did not understand them letting me go.

When I was 15, I worked for Mr. Crawford's Dutch Maid ice-cream shops. I scooped ice cream. Our uniforms were red and white checked, with little caps for our heads. We had

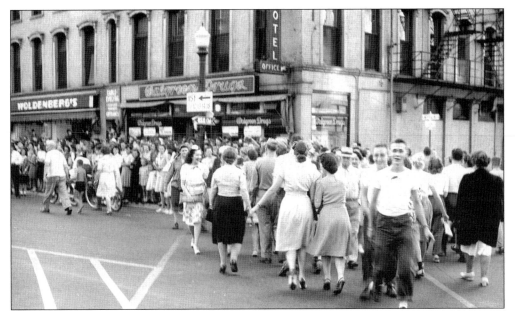

This photograph of the V-J Day Celebration on the Capital Square was taken on August 15, 1945. (Courtesy of Wisconsin Historical Society, WHi-33747.)

to wear hairnets, too. The main store, where the ice cream was made, was on University Avenue. The store I worked in was in the first block of Mifflin Street on the Square. Mr. Crawford also had one on State Street and one on Atwood Avenue.

I was working at the Dutch Maid on V-J Day. People were running past screaming, yelling, utter chaos—"The war is over! The war is over!" We closed the store; most of downtown closed. There was dancing, people came out from every place. Everyone was so happy.

We moved during my senior year from 217 North Hamilton Street to 542 West Johnson Street, and I changed jobs from the Dutch Maid to the Caramel Corn Shop on State Street. I got a nickel more an hour. Walter Burns made his own caramel corn in a great big copper pot right in the front window, and I would help him. That was very good for meeting people! But I had to clean that big copper kettle before going home at night.

I met my husband-to-be, Rich, while I was in high school. My mother liked him, which was not a good sign! Mother went to work at Kelly's on the night shift, working from 11:00 at night until 7:00 in the morning. Rich worked for A. J. Sweet fruit company after

school, loading the truck. He would come in to Kelly's to take coffees back to the fellows.

Coffee "to go" was put in half-pint glass milk bottles with little caps. I was at Kelly's one night after dark. He came in for the coffees to go, and Mother said, "Richie, would you take Jackie home?" I said, "He doesn't have to do that." She said, "Then I have to call Hugh, because you aren't walking home alone." Richie had a Model A, a horrible little car. He took me home, that is how I met him. (We did not marry until much later, after the Korean War.)

My mother did not believe higher education was necessary. Hard work would get you where you wanted to go. With any encouragement, I might have gone on to college. There were many people in the world at that time for whom education was important, but not to my family.

My mother expected me to work at her restaurants after high school.

Fortunes improve during the war, leading to Dolly's restaurants

During the war, City Cab allowed you to own your own cab, and my stepdad Hughie owned ours. That was our first upward economic

move. The cabs ran back and forth from Truax Field all day long. He drove as many as 20 hours a day on weekends. There were not enough cabs to take care of all the business.

In about five years, my family went from renting to owning property. They purchased three houses downtown; we lived in one and rented out the other two. Mother built three garages behind the Butler Street house and we rented those and the yard for parking.

The war brought prosperity to Madison. The cab business was a good one. The restaurants were full. The waitresses made good tips. That was when Mother decided she could have her own restaurant. They worked, they saved, and on March 1, 1948, they opened their first restaurant at 616 South Park Street. Of course they called it Dolly's, for my mother.

Hugh died on March 13, 1948. Dolly remarried the following year.

Like Mr. Crawford and his ice cream shops, my mother was never content. She liked running restaurants. She opened a second restaurant on Regent Street two years later. She opened a restaurant on the first floor in the Washington Hotel a year later. Then they opened Dolly's at Ashton Corners. At one time, they had four restaurants. Years later, after some of these closed, they opened the Williamson Street Dolly's. Michael Feldman's began broadcasting his radio show *The Breakfast Special* from Dolly's Fine Foods on Williamson Street in 1977.

I worked in her restaurants, off and on, until 1979. I liked the restaurant work, and the customers, but I did not like it when the people who came in were with someone else's wife. They would be coming in the daytime with their wife and kids and at night with their girlfriends. My mother said, "Whatever they do it is none of your business."

Dolly's hard-working brand of charity
Times were hard, especially for widowed or single women, who had very few ways of earning a living. We would always buy one item from the Avon lady every two weeks—we knew that was her only source of income. We would visit a farmhouse where a woman made rugs out of rags. They smelled bad, but we always bought them, because she needed the income.

It was an honorable time. People used to come in to the restaurants hungry. Never would you turn anyone away, but you always gave them a job to do. They would sweep our floor, or wash the window, whatever needed doing. People did not beg, they had their dignity. They would work for something to eat.

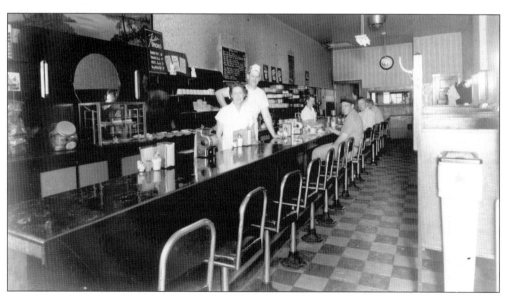

Seen here is the interior of Dolly's first restaurant, located at 616 South Park Street. The photograph was taken in 1948. (Courtesy of Jackie Mackesey.)

DOLLY'S RESTAURANT

616 S. Park St. — 1103 Regent St.

$5.50 VALUE FOR $5.00

Name ..

Address ..

A Dolly's Restaurant meal ticket was a $5.50 value for $5. (Courtesy of Jackie Mackesey.)

We used to hire our dishwashers from the Madison jail. My mother would be delighted when she heard that one of her favorites had been arrested, because when they came out sober, they were hard workers.

Many people remember Snowball—he used to wash our windows, and he would come in to eat at the end of the day. We always had a special of the day, which was 65¢. It would be soup, bread and butter, vegetable, potato, meat loaf or roast beef or roast pork, whatever the special was, and a beverage. Whatever was left on the steam table, that was what Snowball wanted. We could count on him to come.

I liked all our customers, all kinds of people.

The lessons my mother taught me—her wisdom, her courage, her example—and her unwavering belief in me sustained me for a lifetime.

A prettier, friendlier Madison

I no longer encounter the owners of stores when I shop. In those days the owner was actually in the store and you talked to him, you knew him. He welcomed you, he was happy that you were there. My neighbors were stores, not homes. I felt that they all took care of me and watched out for me as if I lived in a lovely suburb. Everyone knew who you were.

I ran all over doing my mother's errands. There was safety at all times.

Madison was prettier to me at that time than it is now. It was friendlier, smaller, and I miss all the walking I did. I would walk anywhere to save a nickel. I love the addition of our Farmer's Markets, but I miss going to the farms and buying a chicken, buying eggs, buying vegetables.

Jackie and Rich Mackesey were married after he returned from the Navy. The couple have seven children and nine grandchildren. The boys all loved the Green Bay Packers and made watching their games a festive family occasion. All but one of the Mackesey children moved away from the Madison area. Celebrations

63

such as baptisms, confirmations, birthdays, and Christmas bring the extended family together in California, Colorado, Michigan, Texas, Virginia, and Wisconsin. Jackie and Rich are retired and live in Cottage Grove, but spend a lot of time traveling for the love of it and to stay in touch with their widespread family.

Eight

WINNIE LACY, MARQUETTE NEIGHBORHOOD

My name is Winifred Mae Lacy. My maiden name is Lottes. I was born in 1933.

My parents lived at 1114 Williamson Street when I was born, and I lived there until shortly before I married. My father was German. He was a plumber. During the depression, he worked out of the Union Hall. Beer came back in March 1933, and after that, my dad got a job retooling the equipment down at the Fauerbach Brewery.

My mother was half German, half Irish. She worked as a housekeeper, in a bakery, for sorority houses. During the war she worked for a company named RMR, at the corner of Washington and Dickinson Streets, she worked at Research Products, things like that.

I have one brother, about three and a half years older than I, named Jim (Jimmie). My grandmother lived upstairs until she died, when I was in the fourth grade.

Winnie Lacy's house was located at 1114 Williamson Street. (Courtesy of Winnie Lacy.)

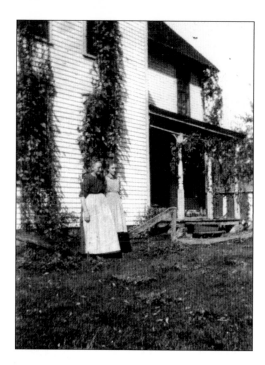

Winnie's mother and grandmother are photographed in front of the farmhouse in Pine Bluff. (Courtesy of Winnie Lacy.)

We used to visit the farm where my mother grew up, and I used to spend some time out there in the summertime—berry-picking, riding the horse, bringing the cows in, playing in the hayloft, all that kid stuff.

My mother's father had died when she was about 12, and she was needed to work on the farm. She always regretted—regretted is not a powerful enough word—that she did not get to go to high school. When she had time, when things were slack on the farm, she would go up to the grade school, and the teachers would help her, let her read books.

In Pine Bluff, there was very definitely an Irish and a German side of the community. The Irish sat on one side of the church and the Germans sat on the other side. Every committee had an equal number of Irishmen and Germans on it. The priest would preach in German and the Irish men would get up and walk out and sit on the front steps until the sermon was over.

Play, work, and chores in my Williamson Neighborhood

I grew up with the Depression hanging over my head. There was nothing frivolous. I remember my mother saying they had to sell the kitchen stove in order to pay the doctor bill when I was born. I wore my brother's hand-me-down clothes long before it was fashionable for girls to wear blue jeans. Things were tight, but there would be a nickel to go to the movies on Saturday. I do not think we felt deprived. Everybody was in the same boat as we were.

In the 1100 block of Williamson Street, the area behind our house was all open. The railroad tracks for the Milwaukee Road and the Chicago-Northwestern ran back there. The trains were frequent.

Part of the area was a little higher than the other, and people had dumped cinders from their coal-burning stoves there. We called that "the cinders," and that is where we played baseball and basketball. The rest we called "the marsh," because in the spring it would be very wet. That was a lot of open space.

There were lots of boys in the area to play with. I played baseball. I played basketball. I played football. I climbed trees. I did not swim, because my mother thought the lakes were too dirty.

In the summertime, we played outside until it would get dark. We used to play kick the can, hopscotch, red rover red rover, and a variation on hide-and-seek.

When we came inside, card playing was big. Five-hundred, dirty clubs, canasta, and euchre.

Winnie Lacey's playground was "the Marsh"—an undeveloped area bounded by railroad tracks and industrial buildings. The McClain Distributors and Gisholt factory is visible behind Winnie's brother Jimmie and his friend Charlie. (Courtesy of Winnie Lacy.)

The neighborhood kids' basketball hoop is seen with "the Cinders" in the foreground, and "the Marsh" behind. This photograph was taken looking east, with Wilson Street to the left, and houses on Few Street visible in the background. (Courtesy of Winnie Lacy.)

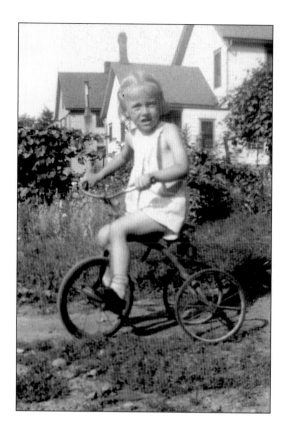

Winnie is seen riding her tricycle behind the house on the back driveway. (Courtesy of Winnie Lacy.)

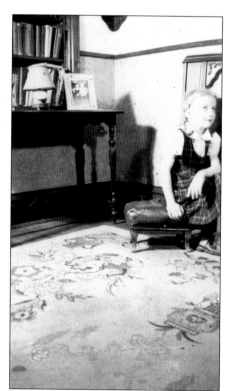

Winnie is listening to the radio. (Courtesy of Winnie Lacy.)

Filipino soldiers stationed in Madison during World War II had a baseball team. Some of the players posed with Winnie for this photograph taken in front of the Breese Stevens Field main entrance, looking toward Paterson and East Washington Streets. (Courtesy of Winnie Lacy.)

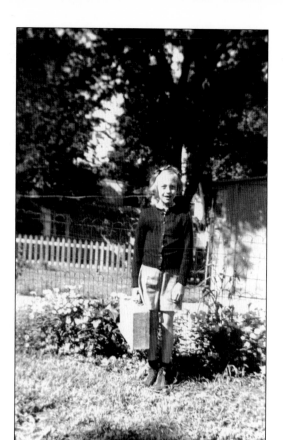

Then there were board games—Monopoly, Parchesi, Chinese Checkers—played as a family or at friends' houses in the neighborhood.

And we used to listen to the radio, *The Lone Ranger, Little Orphan Annie, I Love a Mystery, Lux Radio Theatre,* all those programs. Fred Waring's music program was my favorite.

Baseball was my summer activity. The Industrial League played baseball up at Breese Stevens Field, and I lived there. It was strictly amateur, they just loved to play the game. Different businesses would sponsor teams. There were teams for Kennedy Dairy, and Bowman Dairy, and Gardner's Bakery, Badger Sports, City Car Cab, Huegel Hyland Riley, Penn Electric. Three or four nights a week, it was the place to be.

I started taking care of a little neighborhood boy when I was probably 10 years old. I would take him to Orton Park, and for walks through the neighborhood, and things like that. My mother made me give back some of the money I was paid. She said it was too much for just playing.

Saturday chores, Sunday church

Saturday was cleaning day. Cleaning the bathroom and sweeping down the front stairs was my job. Later on came the vacuuming and the chore that I hated with a passion, taking the pillows off the couch and vacuuming the couch. Ironing, I started with the flat work like the dish towels and the handkerchiefs. My mother always did my dad's white shirts, but I did other ironing.

I am a cradle Catholic, so religion was always part of our life. On Sunday mornings, my dad always went to 7:30 a.m. mass at Holy Redeemer. The children had to go to the 9:00 a.m. mass. My mother went to early mass at St. Patrick's—it was just the Irish in her, we could not get her to go to Holy Redeemer.

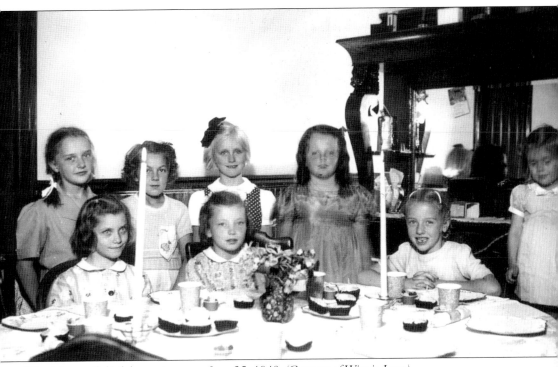

Winnie's seventh birthday party was on June 25, 1940. (Courtesy of Winnie Lacy.)

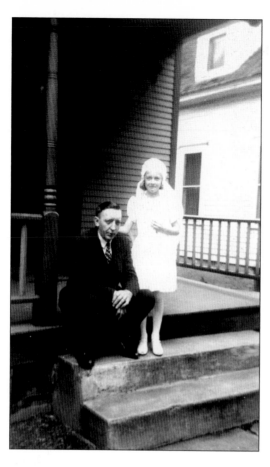

Winnie is photographed with her father on the occasion of her First Communion. (Courtesy of Winnie Lacy.)

Sunday morning was gathering time at our house. Various friends and cousins would stop by after church for coffee and kuchen, a coffee cake made with raisins and cinnamon. My mother was famous for it.

Mother went to early mass to be home in time to cook the traditional Sunday dinner. She would make roast beef, mashed potatoes, vegetables, and usually peas or corn. Mother usually cooked a small pork roast in the pan with the beef and it made very good gravy.

Neighborhood stores and characters

Not long ago, I was in the Williamson neighborhood with my granddaughter, telling her what used to be where, and she just could not believe there were so many grocery stores. There was a grocery store on the corner of Ingersoll, and there was another across the street from it, on the corner where Mother Fool's coffee shop is now. Then there was a grocery store at Few Street, and Flesch's in the

middle of the block. And there was another grocery store down in the 1300 block. It depended on what you wanted, where you went to shop. The little one where Mother Fool's is, that is where my mother always bought her meat.

My mother was quite a card. One time, she was going to get a pound of hamburger, she made some comment about the price, and the butchers said, "If you drag it home behind you like a puppy dog you can have it free." They double-wrapped it and tied more string on and they stood and watched her drag it across the street. She got her pound of hamburger free.

There were grocery stores and drug stores, and repair places and restaurants, taverns, the Fair Store—that was a dime store—and Weber's Bakery. To be able to go up and buy some sweet rolls, that was really an occasion.

I remember bakery smells coming from the Gardner's Bakery over on East Washington

Winnie is photographed with her mother and brother Jimmie. (Courtesy of Winnie Lacy.)

Avenue at Paterson Street. Over there was also the Keeley Candy Company, in the basement of one of those buildings across from Breese Stevens Field. On our way home from school, we would stop and sit in the windows and watch these woman wrapping chocolates down in the basement. Finally, when they could not stand it anymore, they would come out and give us each one piece to get rid of us.

A blacksmith named Vic Hein kept a horse in a little barn right behind our garage. He had just the one horse, a trotter named Jake. My brother remembers him training the horse, out on the cinders.

You did not go to the store to buy milk, you got it from the milkman. The Kennedy Dairy man would come with a horse-drawn wagon. Bancroft and Bowman's had motorized trucks. There were three different dairies. We took Bancroft milk, because it was union. My dad was in the union and we shopped union because that was quite important to him. All the milk and beer bottles were returned to the dairies and breweries for refilling

And of course some people still had iceboxes. The ice truck from Oscar Mayer's would come through, and the people who had iceboxes put a card in the window, indicating which way they wanted their ice—25 pounds or 50 pounds. Depending on which way the card hung, the men knew how much ice to bring in. The man would chip it off there, and he would take those big tongs and throw it up over his shoulder and come into the house with this chunk of ice. We kids were always there waiting for chips of ice.

There was the junk man who would come through and buy rags and iron and metal. During the war, there were paper drives for newspaper, drives for flattened food cans. Kids would save cigarette wrappers and peel the foil off and make big balls out of it and get our nickel for it, and go spend it just like that, on an ice-cream cone or something.

Each neighborhood had its own street sweeper, and he was a common sight. Our street sweeper was an Irishman, short, and just about as big around. He made his first rounds early in the spring, sweeping up the sand left in the gutters from the winter sanding crews. Salt on the street was unheard of then. He made his appearance in the morning, with his push broom, his scoop shovel and his wheelbarrow. He worked the length of the block, sweeping the grit into a pile, scooping it up, emptying it into his wheelbarrow and starting over,

73

The family dog, Jeff, fetches one of Dad's rubbers. (Courtesy of Winnie Lacy.)

bringing the next wheelbarrow back to his main heap, until the entire block was swept clean. In the afternoon, a city truck would come by and the large pile would be loaded into the truck.

Throughout the summer, the street sweeper would make regular rounds, sweeping up the grit from everyday traffic. And in the wintertime, I think that he was the same man who used to shovel the sidewalks at the intersections.

One of the memories of my childhood was watching the trains that ran along Wilson Street. Where the tracks crossed Ingersoll Street was a small shanty where the flagman, Mr. Ehlert, kept guard. It was a small wooden structure, probably no more than three feet by six feet. The flagman had a chair, and in the wintertime a potbellied stove. I remember going down and sitting on the step of the shanty and talking with him. He had a small vegetable garden to the west of the shanty that he tended in the summertime. After the train left for Milwaukee around 10:00 at night, his duty was over, and he crossed the tracks and went to his home, which was the last house before the tracks on Ingersoll Street.

Our dog Jeff counts as a neighborhood character. Jeff could sit up and beg; he could "hit the deck" (roll over); he could speak when asked; he could bring Dad's slippers to him. In the summer, when the door to the porch was open, he could bring the afternoon newspaper into the house.

On Sundays, we would often have a pint of ice cream for dessert. The square of ice cream would be cut in four pieces, one for each of us. Then Mother would cut a small corner off each slice, place it on the ice cream container, which had been opened flat. Then Jeff would have his dessert. He would lick each little triangle of ice cream until it reached the edge of the box, and turn around and lick on it again until it reached the other side. And so it went until all four triangles were consumed.

In the summer Jeff would go out on the porch swing to nap in the afternoon. About 4:30 p.m., he would wake up, stretch his sleepy bones and then turn toward the corner and watch and wait. When Dad would come around the corner from the bus stop, Jeff would raise himself up on his hind legs, front paws on the back of the swing, and his tail would start to wag. At first ever so slowly, but when he was sure it was Dad the tail went into full motion.

Trouble, in school and out!

I went to kindergarten at Marquette School. Then for first grade I went to Catholic school, down at Holy Redeemer. The first week or so, I was just petrified. My grandmother used to come up for the 8:00 a.m. mass every morning, and I would meet her out in front of the church after mass was over and say "Grandma, I'm sick, can I go home with you?" And she would bring me home. Finally my mother caught on, and she took me up to Marquette. (The school stood where the Willy Street Coop is now.) I can remember standing there where the fire station is and looking across at that whole yard full of those kids playing and I was just dashed. I was going to have to walk through those kids to get over to the office to register or something, and I just could not handle it. I started crying and crying. She took me back home. After that incident, I ended up going back up to Holy Redeemer and made it through.

Holy Redeemer was located on West Johnson Street, off of State Street. We had a neighbor we car-pooled down with. After school, we either walked home, or took the bus for a nickel. And that is when I got into trouble. It was wintertime. I was in third grade. It was February 26—1942 sticks out in my mind.

At the foot of King Street there was an empty lot that sloped to Lake Monona. Between the railroad tracks and the lake was kind of a nothing-land.

City trucks used to come and dump huge piles of snow from the roads there. We—my brother, myself, and two kids from the other end of the block—were climbing on those, having a good time.

Then I said, "I've got to go to the bathroom. I want to go home." I think it was about three degrees above zero that day. I was in a big heavy snow suit. And I had a book bag, and a lunch box. My brother did not want to go home, I started out, and the older of the two boys, Charlie, came along with me.

We came to the police boathouse. In front they had chopped a hole in the ice, so that in

Winnie and Dick are "lost" at Holy Hill. (Courtesy of Winnie Lacy.)

Winnie (left) is photographed on her first day of high school. (Courtesy of Winnie Lacy.)

the spring the ice would not break the dock. We were going to take a shortcut past the boathouse on the ice. I put my foot onto that ice to see how thick it was and, at the same time, as I recall, I was turning around to holler at my brother, to say, "Hurry up, I've got to get home!"

And in I went! With my heavy coat, jacket, the whole bit. Charlie was right there and he pulled me out. Oh, I was soaking wet! And besides that, dirty. They put me up against the snow pile to dump the water out of my boots.

We got down to the corner they call Machinery Row now and a squad car pulled in there. The boys formed a cordon around me so they could not see I was wet, because then they would know we had done something wrong. We walked right past the squad car instead of asking for a lift home. That was in the 600 block, and we walked to the 1100 block, with me soaking wet. And three degrees!

My brother said, "When you get in the house, go right to your bedroom and change. Don't tell Mother what happened." So I went in the bedroom and started taking off my clothes, and Mother said, "What's the matter with you?" She knew there was no way I was going to come home and change my clothes. "I fell in the lake." I wailed.

I tell you, there were a lot of long faces, because the lake was really deep there. But I never got disciplined for it. Many years later, I had a baby on February 26. His middle name is Charles, because it was Charlie who pulled me out of the lake on that same day so many years before.

Family friends and trips

We visited with relatives back and forth. The ones I remember best were friends of my mother. They all grew up together in Pine Bluff. This family, the Kalscheurs, lived in Middleton and used to come visit us with their kids and we would play whatever while the adults played cards.

I remember a trip with the Kalscheurs. The parents, Frank and Dorothy, and their children, Ron and Peggy and Dick, and my mother and dad and my brother Jimmie and I, we went all in one car to Milwaukee. My dad and Frank sat in the front seat with Ron between them because he was the biggest. Mother and Dorothy were in the back seat with Jimmie and Peggy, and Dick and I were on little folding camp stools in between. I don't know what kind of car it was but it must have been a fairly good-sized one!

We stopped at Holy Hill. Dick and I were walking and all of a sudden we looked around, and there was nobody there—we were lost!

High school, first job

I went to Edgewood High School. At that time, Edgewood used to give a scholarship to one person from each of the Catholic grade schools and I won the scholarship my freshman year.

As school began, I was given a locker partner. I went home and said, "My locker partner is Ellen Lacy." And my mother said to me, "Ellen Lacy! Oh my goodness, my pa used to date her grandma." We became great friends. I would stay overnight at her place (a farm outside Fitchburg) or she would stay overnight at our place in town.

I worked while I was in high school. My first job was as a page at the Sixth Ward Library, three afternoons a week. The library was down in the 1200 block of Williamson Street. It was the Griegg Club for a long time after the library closed. I used to shelve books, and when there weren't books to shelve I would repair books.

There were two tasks that I did not like to do. One, I had to go knock on doors and tell people their books were overdue. I had to go to what we called the Transient House, down on Baldwin Street. That was where men lived who did not have any place else to live. The librarian told us to just go in and start looking under chairs and under the sofa—she was sending a 15 year old girl to do that! I did not like that at all. The other thing I hated was her sending me over to Dolly's restaurant to get carry-out supper for her.

From high school to the world beyond

High school football and basketball games were important when I was in high school. Madison Recreation used to have a Saturday morning basketball league and we used to play a lot of games down at Marquette School.

I don't remember parties as such during high school. I went to a couple of mixer

Seen here are three basketball "stars" at Marquette School. Winnie is the one in the center. (Courtesy of Winnie Lacy.)

dances when I was a freshman, but it was a long way to come back home to Williamson Street from Edgewood at night. I went to junior prom, one of the most highly overrated occasions in a young woman's life. Ugh!

I graduated high school in 1951. All the kids in my senior class in high school were looking forward to going to the university. I had it in my mind that I wanted to be a dental hygienist. I was getting information from Northwestern, and I had no idea what they were talking about: credit hours and such. My folks said, "If you want to go to college you need to work a couple of years and earn some money." So I started working as a dental assistant and stayed at that until I got married.

After high school, my friend Ellen went to college and I went to work, and we kind of drifted apart. It must have been about 1956 that she and I started seeing each other again. That is how I met Phil Lacy, her brother. Ellen and I were going to a dance one night up at Turner Hall, and she said to Phil, "Why don't you come along?"

Then Ellen and I moved into an apartment together, near St. Patrick's on South Hancock Street. I needed my sewing machine up there and I did not know how I was going to get it up to that little furnished apartment. Ellen said, "I'll have Phil get the truck and bring it," so he came in one night and we got the sewing machine into the apartment. We started

working on a puzzle and I think he left about 2:30 in the morning.

Ellen and I were on a bowling team and he would come out after chores and we would get a beer or two. One thing lead to another, and all of a sudden we were getting married. We were married in 1958.

When I think of my childhood, I think of carefree days playing in the cinders and the marsh, going to Vilas Park for fireworks, and making ice cream in the back yard when the cousins came back from the war. We did not have a barrel of money but everyone got along. In our family there was always lots of close, family fun.

Winnie and Phil Lacy raised seven children. The newlyweds started out farming in partnership with Phil's brother. Later, Phil went to the Wisconsin School of Electronics and pursued a career in computers. The couple now resides in Fitchburg, within sight of the old Lacy family farm. Winnie stays in touch with her old neighborhood through the Friends of Historic Third Lake Ridge.

Nine

MARGARET INGRAHAM, NAKOMA NEIGHBORHOOD

I was born in 1937 in Toronto, and put up for adoption, because my mother was not married. I was raised by a wonderful Madison couple, Alex and Edith Brink. The name Brink is Dutch.

My father and mother were Canadian. They met in high school, in Woodstock, Ontario. He went off to graduate school at Harvard, and when he was offered a position in 1922 at the University of Wisconsin, he went back and married his high school girlfriend and brought her over to Madison. He became a genetics professor.

They had a dream of designing and building a house. They bought three lots in Nakoma on Manitou Way in about 1930. The house was called the Tree House. My father would come out from the University to Manitou Way at the end of the working day to see how the contractors were doing. One day, he saw a rope wrapped around the most beautiful oak tree on the property. He told the contractors, "You may not remove this tree!" And they said, "but it's in the middle of where we're building the house." So he said, "Then you will build the house around it." Well, they thought he was nuts, but

The house the Brinks built is seen here, photographed in 2005. (Courtesy of Margaret Ingraham.)

they built the house around it. There was a screened porch and the tree just grew right up through the middle of it. Squirrels used to run up and down the tree and into the house.

My brother, Andrew Brink, was their natural child, born in 1932 by cesarean section. In those days when a woman had a cesarean birth, she was told she was not strong enough to withstand another birth. That misinformation led to my adoption, and led to my mother not having the four or maybe six children that she had planned on.

My parents started trying to adopt almost right away, but it took them six years. My mother's sister in Toronto was a social worker who placed children for adoption. Once I had been found by my aunt, there were still a lot of hurdles to get over.

It was extremely difficult for my parents to adopt because they were not members of any church. You had to swear that you would raise your child in a certain religion. My father, the scientist, found it difficult to accept any religious beliefs. In order to adopt they had to tell a little bit of a lie. Some good friends of theirs, the Daniels, attended the Congregational church. They spoke to the Reverend Swan who wrote a wonderful letter on my parents' behalf, saying they were members of his church, even though he had never met them. My parents were so grateful to him that when I was old enough, my mother sent me to his Sunday school.

My mother would tell me beautiful stories about searching for a baby, "We looked all over for you," and I had this image of the whole globe.

From the beginning, an actress

When I was three or four, there were a lot of houses being built in the neighborhood. I could hear all the pounding and sawing. I went off one day to explore. My mother looked out, I was supposed to be out in the yard playing and I wasn't.

The neighbor women started driving around looking for me. They eventually found me at a building site. There I was collecting nails, and just having a fascinating time looking at all the construction.

But my mother was very concerned about my drifting away like that, and very concerned that I not do that again. For punishment, I was put on the dog's chain, out in the front yard. I could see the mailman coming up the street and I thought, "Oh no! He's going to see me tied up." It was terribly embarrassing. I solved the whole problem by getting down on all fours and barking at him! He never knew that I wasn't the dog—he even patted me on top of my head.

I have a memory of when Pearl Harbor was attacked. I was four years old. My father was taking a picture of my brother and me for a Christmas card. My mother had decorated with greens along the banister. While he was taking pictures the radio was on, and the news came across.

Suddenly, the picture-taking stopped, my mother came in from the kitchen, everybody huddled around the radio. The family went from one mood to the absolute opposite. I remember that vividly, "What happened? Take my picture!" I did not understand at all what was going on. They just went into another world. I could not go there, and I remember the confusion that I felt.

A world of university people

My father was a plant geneticist. He was not a man to spend time around home with his children. He was a very intimidating man to me, so off in his intellectual world that he would not deal with the simple things.

A friend of his was Sewall Wright, a brilliant geneticist. As a child, I watched him look at a pop-up toaster and take a piece of bread off the plate and try to figure out how you use this. That was too simple an idea. I remember watching this with great amusement and absolute astonishment, that he could not figure out to drop it in one of those slots, push the lever down, and it pops up!

Then there were the Ingrahams. Mark Ingraham was a math professor, who later became dean of the College of Letters and Science. Katherine Ingraham was a remarkable artist, an interesting woman, but she grew up in an era where she was not allowed to do her art and be who she was, because she had to be a wife and a housewife, and have meals on the table. Mark Ingraham was a wonderful man, but he was a man who felt a woman's place was in the home, primarily the kitchen.

Shown here is Alex Brink's photograph taken for the family Christmas card on Pearl Harbor Day in 1941. (Courtesy of Margaret Ingraham.)

Margaret, at age three, posed for a photograph, reading with her mother and brother. (Courtesy of Margaret Ingraham.)

Margaret and Andrew are photographed in the yard, around 1943. (Courtesy of Margaret Ingraham.)

Farrington Daniels was a chemistry professor. He and his wife were very close friends of my family. I grew up with all these incredible university professors, taking it for granted that this was the world.

Life in Madison then was not the real world at all. Growing up in an academic home, I was protected from the world. I was certainly never taught prejudice, which I am grateful for. It did not exist in our home at all. I never ran into it until I was an adult in the real world.

A love of nature developed early

When my parents first came to Madison, they used to get on a train with a picnic and travel up to Okee, a little north of Lodi. They would walk up one of those bluffs over the Wisconsin River. They fell in love with one particular bluff.

They started inviting the Ingrahams to come with them. For years the Brinks and the Ingrahams went up and picnicked on this land, and they started calling it "the Hill."

About the time the war broke out, the Ingrahams bought the Hill. They always considered it ours, too. They built a couple of tiny rustic cabins, no electricity, no running water.

I always loved it, sitting out on the screen porch or on the hillside, with my parents and the Ingrahams around. It was a heavenly place. The Ingrahams had a daughter who was 11 years older than me. I do not remember her being there. Their son Ed was about my age and around all the time. He would be out chopping wood, or playing catch with his dad or my dad, or something that did not interest me. Even though we were right there in the same spot, we did not really cross paths until we were much older.

Lessons in music and dance

In those days, we had music teachers who came to the houses. I started played violin at age four. My neighbors and I played in a little string quartet.

Music is my passion. I came from professional musicians through my natural mother—she was Spanish, and in her family were concert pianists and opera singers. My Madison parents did not know this at all. I found out when I was about 40, when I met my birth mother. Being raised by a geneticist, I found it easy to ask, "how much is genetic and how much is

85

This is the view from "the Hill." (Courtesy of Margaret Ingraham.)

The Nakoma neighborhood string quartet is seen here. Shown from left to right are Carol Christianson, Margaret Brink, Mr. Schneider the music teacher, Janice Arneson, and Toby Helprin on cello. The photograph was taken at the Arneson house in 1943. (Courtesy of Margaret Ingraham.)

environment?" And with me, there was so much that surfaced that was genetic.

There were other kinds of lessons. As a little girl I wanted very much to dance. I used to take the bus down to the Square to the Katherine Hubbard Dance School. I had this tiny suitcase with my leotard and shoes in it. I went there for years. I took ballet, toe, and tap, and absolutely adored it.

My mother's pleasures and trials

How difficult homemaking was for women in my mother's day! There was no grocery store close by. For household needs, my mother went to the Nakoma Trading Post, across the street from Nakoma School. It had originally been a real American Indian trading post.

My father took our one car to the university every day, so my mother never had a car. She could walk to the Trading Post, and later they would deliver. I can remember the teenage boy coming up the back stairs from our driveway with a cardboard box. That was life-saving for my mom. For other needs, she would get on the bus and go down to the Square, where she would go to a fish market, a meat market, buy her fruit and vegetables, and go to a bakery. Then she would get on the Nakoma bus and carry her groceries home. While she was downtown she went to the library and took out books to read. What a load to carry!

She was raised a small town girl, a very charming and friendly person, but very shy. She never seemed to fit quite right in Madison. My father really became a part of the United States through his work. My mother, not having that work, I think, remained a Canadian, an outsider, a visitor, looking in.

Her close friends were women in the neighborhood, and others who were faculty wives. She was a member of a group of women who called themselves "the Wild Women." My mother fit in beautifully with this group.

In the early spring, when the wildflowers came in, they would take off to Door County, where some of them had cabins. They would go off through the woods and dig up wildflowers and bring them back and transplant them in their own woods and gardens. You would be arrested if you did this today! And they would go off and just tramp around the north woods, and have the best time together. They would wear their old jeans and sweatshirts, leave their jewelry and cosmetics behind.

Leaving their families at home for women of that era meant you did a lot of work before you left. You prepared a lot of food, because you did not abandon your family. They had to work very hard to be entitled to go off into the woods, and they would not go off for very long, unfortunately for them.

My mother never complained. But I can look back on her now and see she was clinically depressed. She had no life.

My father was passionately involved in his work. When he came home he would have supper, then go in his study and shut the door, or he would go back to his lab. My mother did not have anything except cleaning the house and raising her two kids. I would come home from school sometimes in the afternoon and she would put on tea—she wanted me to sit down and tell her what I had done, because she had not had a day.

I did not understand any of this growing up, but now it is so clear to me. She had gone to the University of Guelph, then called Ontario Agricultural College, in Ontario, trained as a dietician. Once she was married she did not feel she could work, she was supposed to be at home with the children. Watching my mother sacrifice her life made me absolutely determined not to sacrifice mine. No man was worth that. And that is what my mother taught me, and she did not even know it, and if she did know, she would probably say, "Oh, dear!"

In high school, acting trumps science

I went to West High School for grades 9 through 12. I was never terribly fond of West High, but some of the classes I liked a lot. There were a lot of courses I did not do well in. I was blindly going ahead thinking I was going to be a nurse. I was taking chemistry courses in preparation for getting into a nursing school.

My parents did my career planning for me. As far back as I can remember, my parents were telling me that I should be a teacher or a nurse. They saw me going off in the "wrong" direction when I wanted to play violin, and when I wanted dancing lessons. They were always trying to pull me back, saying, "That's

Margaret is seen here on a visit to her mother's people in Woodstock, Ontario, in 1958. From left to right are Margaret's mother's sister Jean Whitelaw, mother Edith Whitelaw Brink, father Alex Brink, and Margaret. (Courtesy of Margaret Ingraham.)

fine to dabble in, but you need to think in terms of a practical career, in teaching or nursing." Those were always my two choices.

I picked nursing of the two because I liked the idea of taking care of people, especially children. I always just loved kids and babies. So I allowed my parents to take me in that direction.

My senior year at West High School was absolutely the pivotal point in my life. It spun all the way around and put me where I was meant to be. At one point I had to make a choice between an English course and Speech.

I had no idea what Speech was, but I had certainly taken enough English to get me into nursing school, so I started talking to other students and I found out Speech is a whole variety of things: you read poetry, you read in front of the class, you put on short plays—wow! They all appealed hugely to me. So I signed up for Speech, and that was it.

Ruth McCarty was the speech teacher. We put on short plays. One student would direct and then maybe three people would be in it, so that everybody in the class had a chance. We

Margaret is photographed here by her father when she was 20 years old. (Courtesy of Margaret Ingraham.)

would include props and costumes, like hats or such from our own wardrobes. I had never done anything like this, and I loved it. I heard from someone in another class that McCarty named me the best actress.

I was just absolutely floored! I was not used to being the best at anything. Certainly not in chemistry or biology, not even in orchestra.

A change of course at the University of Wisconsin

After West High, I went to the University of Wisconsin with the idea of taking general course work to prepare myself for nursing school.

When I started at the university, I dated Ed Ingraham. Ed and I found we had a lot in common.

Sometimes you look back on your life and you see how the road was very clearly paved. My university advisor was someone in the theater department. Now how did that happen? I did not choose him, he was given to me. Ordean Ness was his name.

We were allowed certain electives. All of a sudden, I could choose a theater course! I could choose a music course! Well, after two years, Ness called me into his office. He said, "Margaret, why don't you just settle in to the fact that you're going into the theater department?" I said, "No, I am going into the nursing program."

He said, "Look, I'll show you something." He put in front of me my history at the University of Wisconsin for those first two years: the courses that I had to take, and everything that I had elected to take. And everything elected was in the music school and the theater department. He said, "Why would you make these choices if you're going into nursing? It's perfectly clear that you're going to go into the theater department with a minor in music." So I finally thought, "I'd love to take all these theater courses, I'd love to take more music courses. I'd love to not take chemistry."

My father was outraged—the theater department was not an academic area in his eyes.

Enter: the Green Ram

In 1959, the summer before my senior year at the university, I went to the Green Ram Theater. That was a very special place.

It was started in 1957 by Claire Ellen Prothero, who was a major person at WHA Radio for years. We called her Pinky. She had grown up in Baraboo, where her father was the mayor. Pinky had a very idealistic view of theater.

Pinky had this wonderful plan to change the world, change people, make them better through the arts. She really thought that an evening at the theater could make you a better person. It should. That was what all the arts should do for people. That was my attraction to the theater, too.

Pinky had this dream of starting a theater. Her father, to make this happen for her, bought a farm just off Highway 12, northwest of Baraboo on Moon Road.

At the Green Ram Theater, the actors came from all over. My professors from the theater department were there, and the WHA people, who were frustrated actors who had gone into radio instead of on the stage. It was a great group of people. I mean, these were my heroes.

My mother was a bit in awe of the idea of my going off, spending the summer with all these theater people, but my parents knew it was very respectable.

My father really did not like this. The day I left, he refused to give me a ride. His attitude surprised and hurt me.

I took a Greyhound bus. The bus driver stopped right out in the middle of nowhere and he said, "There you are. There's the theater and you're going to the farmhouse, you just hike down that road."

The bus drove away, and I was out in the middle of the cornfields. My heart was beating. It was hot and I was carrying a ton of stuff. Pretty soon a car pulled right up beside me. I heard a familiar voice say, "Hey, little girl, where you going?" It was Ordean Ness, my advisor! Don't you wonder how these things happen? He took me to the farmhouse and just started introducing me around. He was so kind.

Somebody took me down to the bunkhouse, where I would be sleeping. "Take that bunk right up there, and there's the bathroom and don't look over that wall." The men were on that side. It was just plywood, simple as it could be.

I was hired to play the ingénue parts, act in four plays, and spend the whole summer at

Margaret, at 22, is photographed by Ed Ingraham. (Courtesy of Margaret Ingraham.)

the theater. I think at the end my check was something like $200—it was thrilling!

We would rehearse one play, open it and immediately, go into rehearsal for the next while we were performing the first. The schedule went like this: on Saturday and Sunday, we would block the acts; from Monday through Thursday, we would work on the acts; Thursday evening would be dress rehearsal; Friday we did two run-throughs during the day, then opened in the evening; the play ran through the next Tuesday evening; and days were spent rehearsing the next play.

Out there in the rural landscape, we rehearsed in the parking lot outside the theater in the blazing sun. If it poured rain, we would rehearse in the screen porch at the farmhouse. To memorize our lines, a lot of us walked up and down the rows of corn, to get out there where you can talk out loud and memorize.

We performed in the barn-style theater. It was an open air auditorium. We had green and white striped awnings that we would pull down in bad weather. We timed the beginning of the performances so that we would not have to compete with the most beautiful part of the sunset.

I do not think I got any sleep all summer long. I had lines going through my head every minute. We would all go back to the farmhouse after performances, some people would have a beer, and we would talk and laugh and rehash the performance and tell jokes.

It was such an incredibly magical time for all of us who were there. It was the beginning of our professional careers in theater. Some of us are still doing theater work, and our first experience was the Green Ram Theater.

Exchanging theater for marriage

I was proposed to by Ed Ingraham that year. He was a year ahead of me in school, and he was going off to Harvard to get his Ph.D. He did not want to go to Harvard alone, he wanted to take a wife, or a support system.

He wrote to me when I was at the Green Ram, and he was clearing trails in the White Mountains. He started writing regularly. There were a lot of jokes at the Green Ram about, "There's another letter for Margie from New Hampshire." He was almost encroaching upon my special territory with all those letters. He was getting a plan in his head of coming back in the fall and proposing, which he did.

It was really too soon. I wanted to progress in my direction, but I liked him a lot, and I liked his family. So when he proposed, he drove me up to the Hill, where we both had spent so much time, and proposed. I felt I would be an idiot to say no. But to say yes was jumping into something that I was not ready to do. I wanted to act for the rest of my life!

I thought, "He's a good person, he's from a good family, my parents adore him." So I said yes. I married five days after my university graduation, which I did not attend because I was busy packing. We moved to Harvard where he worked on his Ph.D. My parents were very pleased and his parents were pleased. But I missed the Green Ram terribly.

I took a wonderful theater course at Harvard, but Ed didn't want me running around Massachusetts appearing in plays. The course helped me a lot, to be able to at least keep my foot in theater, so to speak. And then in 1963, when we left Harvard, we went straight to the Green Ram. Ed knew that I had to. He knew that it had been his time working on his Ph.D, it was now my time. He ran the box office. We had a very good summer at the Green Ram, but by then we had our first child. I was a mom and I had responsibilities. It was great fun, but that second summer was very different from the first.

Guardian angels

Life was very different when I was growing up here. We left our house doors unlocked in those days. We would go to bed with the doors open to let the cool night air come in. Imagine!

My father was at a loss for how to raise a child, particularly a girl. I think my mother might have had an idea that my blood mother, having a child out of wedlock, was a bit on the wild side, and that was something I might have inherited. So I think she had this incredible feeling of responsibility to see that I was raised well, and safely. I think I was overprotected for that reason.

Growing up in the academic world in Madison was not the real world at all. It was not very good preparation for what I ended up doing. But all along the way, I had these real guardian angels who said, "You go this

way, you stay on that road." They just seemed to pop out at the right times for me.

Margaret's sons, Mark, David, and Christopher, were born between 1962 and 1969. Ed's career in mathematics took the growing family to academic communities in Massachusetts, Oregon, Michigan, and London where Margaret was again able to pursue her interest in acting. Ed and Margaret divorced in 1981. She finished an MFA in acting in 1983 and moved to Chicago where she acted professionally until her return to Madison in 1995. She continues to teach voice (singing) at the Memorial Union Mini Course Program and to coach actors and singers. Her appetite for nature and beauty has led to work with Taliesin Preservation, taking visitors on tours through Frank Lloyd Wright's home, farm, school of architecture, and around his beautiful valley near Spring Green.

Ten

BEVERLY FOSDAL, CAMPUS/DOWNTOWN NEIGHBORHOOD

I am Beverly Fosdal. Mickelson is my maiden name. My birth date is August 21, 1942.

I guess I was born in Madison. My parents moved temporarily to West Virginia after I was born. They were divorced in 1946, and my mother, my sister, and I moved back to Madison. I was about four years old.

There was not much aid for single moms then. The only job my mother could get was housekeeping. She was able to keep me, but she was not allowed to have my 16 year old sister in the house as well.

So my sister Arlene had to go out and find her own place to live while she finished

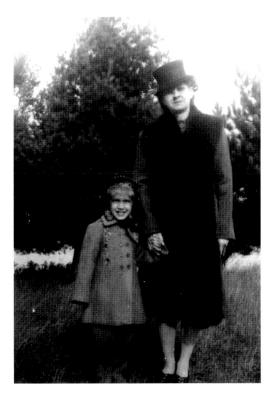

Beverly is seen with her mother, at three years old. (Courtesy of Beverly Fosdal.)

Seen here is Beverly's kindergarten portrait. (Courtesy of Beverly Fosdal.)

The Murray Street boarding house is seen here, painted by one of the student artists. (Courtesy of Beverly Fosdal.)

high school. She was taken in by a family as a housekeeper, cook, and baby-sitter. It was a very kind family.

At East High School, her guidance counselor said they could help her get a scholarship to go to Methodist Hospital Nurses' Training School. Our grandparents were opposed to nursing. They thought that "women of ill repute" become nurses. Was it because one might possibly see a man's nude body? Our mother thought nursing was great for Arlene. She was able to complete nurses' training. Her early life was tough, but she rose to the challenge.

A very independent young girl

We moved to 515 North Lake street when I was five years old. My mother had found work as a housekeeper at an undergraduate girls' rooming house. I remember one of our boarders was a lady named Hildy. She taught me to read, from the newspaper. Every day I would go sit in her lap in her room. My mother was so very busy that I remember this as my "adult contact." One day Hildy said, "Beverly, you're smart!" I have always remembered that.

Student boarders like Hildy were my friends. We had students who were in the psychology department, and they needed kids to give tests to, and I would always be game. Go up the hill, answer a lot of questions—that was fun.

When I was seven years old, my mother got a new job and we moved to a house for female graduate students on Murray Street.

I had mostly neighborhood boys to play with. We would have adventures, make up stories. When we were 10 or 11, the campus was our playground. One of the fun buildings was Science Hall, which had an enclosed metal fire escape around at the back. We would start at the bottom and climb up—it got steeper—and at some point we would fall. Very noisy, and ever so often they would throw water down on us.

We played a lot at the Memorial Union. Our goal was to stay away from personnel, so we would go meandering through the little passageways and hallways. We would be the detectives and we would pick somebody to be the bad guy, and just follow him around.

Acting by accident

Down under the theater area was a warren of little rooms. One time we were down there and we darted in front of a door and somebody said, "Wait a minute. This is the

Beverly is playing at the Wisconsin Memorial Union. (Courtesy of Beverly Fosdal.)

room, Come in here." We were sure we were caught.

We went in, expecting to be chastised, but the woman said, "You're here for the try-outs, aren't you?" So we said, "Sure," and we tried out and all got parts in *The Pied Piper of Hamlin.* That was the beginning of my acting career.

I think I was happy back then. I enjoyed doing things out of the house with my friends. My mother was working very hard, and as a result I became very independent, self-sufficient.

Which caused a problem when I was 10 years old. My mother remarried and was now an at-home mom, and I was long gone. It was hard to have her start telling me what to do, because I had been on my own for six years.

Successful at leading a double life

In my mother's rooming house on Murray Street, she and my stepdad lived on the first floor. The dozen or so roomers lived on the second floor. There was this little attic room up on the third floor, and this was mine. And I had a fire escape!

Around seventh grade, many a night I would sneak out my fire escape and jump onto the garage roof and swing off the clothesline. I would walk State Street, University Avenue, just being cool, thinking I was smart, smoking cigarettes, at 2:00 in the morning.

For my seventh grade school year, I began to attend University of Wisconsin High School, a private school on campus, on a scholarship. Most of my classmates were college-bound, children of professionals. They were doctors' kids, lawyers' kids, kids whose parents owned a business, and they all lived in very nice homes, in Maple Bluff or Shorewood. I kind of felt left out.

When you are the left-out kid, the one group that will always accept you are the bad kids. The kids who are doing things a little bit wicked. So you start smoking cigarettes, and you go to somebody's house, you steal an inch of whiskey and gin and whatever was in liquor bottles, and you mix it up and you think you are so terrible.

I could get into an awful lot of trouble on weekends, and yet I could do well at school.

When I was in the seventh grade, I got to be in the Wisconsin Players production of *The Innocents* at the Wisconsin Union Theater. There were only four speaking parts. And

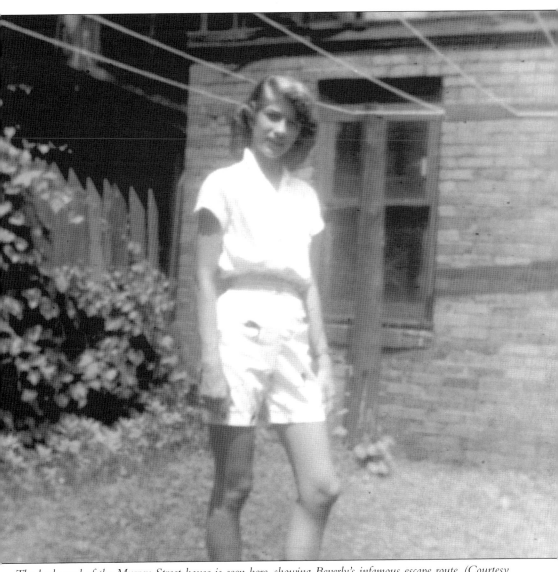

The back yard of the Murray Street house is seen here, showing Beverly's infamous escape route. (Courtesy of Beverly Fosdal.)

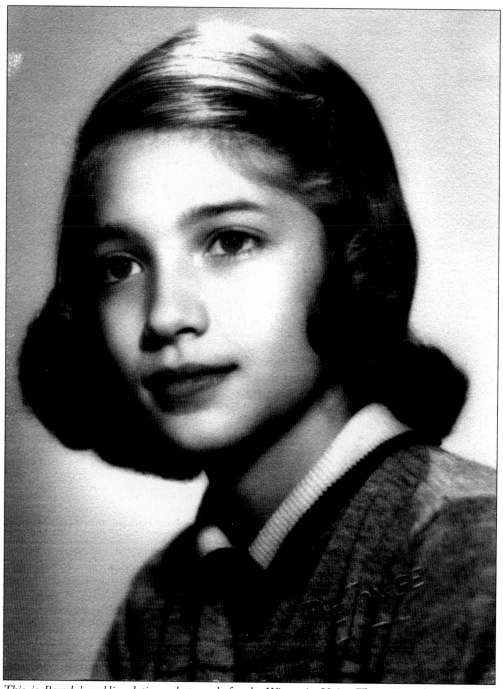

This is Beverly's public relations photograph for the Wisconsin Union Theater's production of The Innocents. *(Courtesy of Beverly Fosdal.)*

Seen here is the Green Ram program. (Courtesy of Beverly Fosdal.)

apparently I did all right as far as the director was concerned, because four years later, when I was 16, between sophomore and junior years, she got me a job at the Green Ram Theater.

By the time I was sixteen, I was successful at leading a double life.

Our family was Lutheran by tradition, but God was never discussed in our home. We were taken to Sunday school for a while, but I did not have any kind of a spiritual conviction of right and wrong. I had no foundation.

My conscience functioned somewhat, and I had my own boundaries. My girlfriend and I would agree basically we were good girls (which of course, basically we were not) because we had our little invisible line—this is okay, that is bad. Premarital sex is bad, but drinking beer is okay. Like that.

All you had to do was tell me not to do something and I would do it. I was part of this little gang. We vandalized billboards. Many of us in this misbehaving group had false IDs, and we would go into bars and drink.

Keep in mind, I grew up on campus. "Yell Like Hell" contests, Homecoming, beer parties, obviously it is the thing you do: drink. And

thank goodness I never ran into drugs. I am so glad, because if I had seen it, I would have tried it. Just the fact that I did not manage to kill anybody with my car, drinking, was fortunate.

Jobs—on stage and off

Out of the clear, in the summer of 1958, just before I turned 16, I got to do two productions at the Green Ram. It was a three-week commitment.

We lived like at camp, very primitive. We had meals in common. We took turns cooking, doing dishes, and cleanup. Rehearsals were outside. They would put ropes down to outline the stage, and try to be under a tree—this was pre-air conditioning.

At the theater itself, you had a boys' dressing room and a girls' dressing room. If you had costume changes, it was fast and pretty public. As a 16-year-old, flat-chested girl, I definitely wanted to go hide in a corner to change, but that was not a possibility. There was just no time.

Summer stock is an impressive thing. You go from zero and in six days you're ready with a production.

Beverly, seen in the center, is acting in Hotel Paradiso *at the Green Ram. (Courtesy of Beverly Fosdal.)*

In August of that year, I turned 16. I remember that day. I walked all the way up State Street and around the Square and down the other side, applying for jobs at every single place. I did not get even an interview. I was so discouraged. And then my mother made one phone call, to a person she knew who managed the Strand Theater, and he interviewed me and hired me. I had so much wanted to do it on my own.

I started out selling popcorn and candy, then I got moved up to be a ticker seller, where you could watch the cars go around the Square. Hour after hour, me in my booth, waving at the boys.

Attempts to bring a double life into focus

By the summer between my junior and senior years, I was again running with the wrong crowd of people. We had a lot of home parties when parents would be gone. We would be smuggling liquor from the liquor cabinet or drinking beer. We used to have swimming parties, somewhere in the Arboretum, at night. We were not supposed to do that. It was great fun.

Unfortunately, I was drinking a lot, and sometimes not coming home at night because I had too much to drink. My friend would go leave a note and sign it for me—"I'm staying at a friend's house"—as if your mother would not know your handwriting.

My mother was concerned, but did not know how to handle it. She apparently talked to my sister, who by this time was married, living way out on the far west side of Madison and had two little children.

One night my sister picked me up after work at the Strand and said, "How'd you like to come and live with us?" I was thrilled. I had always thought that if I had another home, or went to a different school, or lived in a different town, then everything would be perfect. Every child's fantasy.

I was to have rules for the first time in my life. I had chores to do. My sister taught me how to iron, and how to wash clothes. Baby-sitting was a big help to her.

I had never had to do any housework at home. My mother cleaned rooms for those girls every week, and I did not help at all—terrible.

We did not talk a lot in our home. My mother would wash the dishes, put them on the drainer, while I was watching television. Then she would come and watch television

Beverly went to the prom with Jim Henkel—just a good friend. (Courtesy of Beverly Fosdal.)

A post-prom party is seen here at one of the classmate's houses. (Courtesy of Beverly Fosdal.)

and I would go and dry the dishes. When I look back on it, it is very sad. When you do dishes with somebody, it is a great time to talk. We should have done more talking.

That summer, and through my senior year, I lived with my sister. I was very appreciative of being in a home where there was talking, and laughter, communication. That was good!

When I moved in with my sister, I really decided I would not drink any more. I was going to reform and become a better girl. I changed my life for eight or nine months. She got me a job at the Kroger store in their neighborhood. I started out as a checker, trained in all departments except meat, and moved up to the office, handling big money. I worked full time in summer, and kept that job until I got married. All through college, that was what paid my bills.

Running with the Shift Masters

Late in high school and into college, the crowd I ran with were members of Shift Masters—an auto club. We would all go to a drag strip down in Union Grove every Sunday. We were part of the pits. Guys were all working on the cars and the girls were, I don't know, looking pretty, smoking cigarettes, drinking beer. We would go to drag strips and race all day, and then we would bar-hop our way back. By the grace of God I'm alive.

The bad kids were good friends! One of those boys became my boyfriend. Chuck was someone I looked up to, a little older, had a neat car. He was working.

During my senior year, we broke up. That helped me get away from this hard-living group for that last year of high school.

Chuck and I did get back together after graduation, unfortunately. My first three years of college I was going with him, which meant that, since he was not going to college, I did not participate in anything at the university except go to classes. That is one of my big regrets. There was so much at that great university.

College and finding the right man to marry

In 1960, I started attending the University of Wisconsin. I liked science, so I went in as a physics major, because girls do not do physics.

After my sophomore year I thought, "I'm in over my head!" But I also thought, "I want to get out of here in four years," so I looked at Medical Technology. It is a medical profession where you take body specimens, and you go to a lab and do things with them. So that is what I got my degree in: Medical Technology.

Then Chuck and I got engaged. I remember the night he asked me. I thought, "I don't want to get married to him." I knew I was supposed to be excited. I told a few people, but I was not excited. He was a nice guy, but apart from drinking beer and hanging around his car friends, we had absolutely nothing to talk about.

I did not want to hurt his feelings, so I was going to get married, and then get a divorce in a year. My mother had never been negative about her divorce, so I did not see divorce as a big problem. I just saw breaking up with a boy as a painful experience.

I went to visit my sister, and I told her my plan. She said, "Absolutely not! You can't. You have to break up with him."

I remember going home that day, giving him his car keys and my ring, and walking out. And just feeling, free! And the feelings that went along with it—avoiding a close call—I almost married the wrong man. I felt so good, getting out of that relationship.

At this point, I felt, now that I am free of men, what next? The Peace Corps had just started, so I thought, "okay, I'll graduate from college, I'll go in the Peace Corps, I'll travel Europe." And then I decided, now that I was free of him, I would become a new person, and learn sports.

This was winter of my junior year in college. I joined the Hoofers ski club at the university, and sometime in late January, I rented equipment and went on a weekend ski outing. They taught me how to ski, minimally, and it was fun. They taught me how to get up on a chairlift, and that was fine.

So I bought some used skis and boots. The next Sunday morning, I went alone out to Tyrol Basin, which was then called Norway Basin, to ski. They only had a T-bar to get up the hill. With the T-bar you keep your skis on the ground and you lean against a bar that is attached to a spring. You cannot sit down on it; you have to just lean against it and it pulls you up the hill. My problem was, I kept sitting on it, which just dumps you in the snow and crashes you. So that Sunday morning I kept falling down. I would crawl off to the side, brush off, and put my skis back on.

Meanwhile, there was a man up the hill watching this little scene, and if Gerry were telling the story he would say, "I saw this woman fall off the T-bar, get back up, fall off, get back up, fall off, and I said to myself, that must be a Norwegian!"

And he swooped down and asked if he could join me on the T-bar, and I said sure. He talked me through it. He rescued me! And then we skied together, and later on we went into the chalet and he bought me hot chocolate. He was just the gentleman that day.

And this is where the beginning of this whole change came for me. He was from Stoughton, and seven years older. We were trying to find people we had in common. You go through, "do you know Ed Smith from Stoughton?" or whatever, and amongst other people, he mentioned he had met Jesus Christ in a personal way three weeks before.

"What is he talking about?" And I thought, he's religious. Hmmm. He would make a good family man. And, hmmm, he would be safe on a date. Now this is from the girl who was not going to be involved with guys again, who was going to travel Europe, join the Peace Corps, who was relieved to be unattached. Two hours into chatting with this man, and I am already wondering if he would make a good family man. That's women; that's me.

So we skied some more, and he wrote my phone number in the dust on his car, because of course he had no pencil or paper ready. One puddle could have eliminated the whole thing! He called me that night, and we had a date, and we went out every night or talked on the phone for hours.

This was the first man I dated who could talk! And he could talk about anything, whether it was Peace Corps, or politics, or sunsets, or God.

He was Methodist, had not gone to church for many years. He was just beginning to think he should start going. But he had not gotten around to it. So here it was, a Sunday morning, and he found himself skiing. His prayer, on the way to the ski hill that day, was, "God, if I'm

going to be a Christian, I should be going to church. And if I'm going to go to church I'm going to need help. I need a wife. And as long as you're going to bring me a wife, let her be a nurse."

And that morning he met me. When he found out I was in medical technology, which in his mind equaled nurse, they wear white, all the same thing, he really saw that as a hot moment.

Part of our dating was going through the Yellow Pages in the Madison phone book and going to different churches, Sunday morning, Sunday evening, Wednesday night. God became a regular topic for us. He had just joined a little Bible study group. So Gerry and I, after we did whatever you do on dates, go out to dinner, to movies, we would be paging through the Bible, trying to figure it out.

This was in February. In April, I made a commitment to Christ. And then we decided to get married, and got married in July.

At 20 I had left my beer-drinking, Shift Master car club group and change 100 percent. Anyone who knew me a year prior was thinking, whether they liked it or not, there was a definite change.

It was my senior year, the med-tech practicum, the hard year, and I had to learn how to be married. I had never left home. I had never had a checking account. My poor husband!

I went to the library to check out a book on how to wash clothes, wash dishes, how to hang up clothes on the clothesline. Nothing! There was no book on how to hang up clothes, so I just had to look at every yard I went by. I was darned if I was going to ask my mother for help.

I have no regrets. Today I have an awful lot of compassion for kids. You keep your fingers crossed and hope your kids make it through. Fortunately my kids did not have to go as far as I did, because we had some communication set up ahead of time. I learned a lot, but I can understand where kids get messed up—it is looking for something else.

Beverly found work as a medical technician after college, while Gerry continued to work in his family's bakery. The Fosdals bought the bakery business from Gerry's family in 1976 and added a Cambridge bakery to the original Stoughton location in 1985. Keeping the books for the family business provided Beverly with work that satisfied her independent streak and love of challenges until the couple sold the business and retired in 2004. Gerry and Beverly maintained strong ties to church and community, providing a sound foundation for their children, Scott, Mark, and Kristen, born between 1965 and 1971.

Eleven

SUSAN SCHMITZ, VILAS NEIGHBORHOOD

I was born in 1949. I am the fourth generation of a retail family. I have three sisters and a brother.

Bob and Mary Alice are my parents' names. Niederer is my mother's maiden name. Both were born and raised here. My grandparents always knew each other.

It was my great-grandfather Schmitz who started the Hub in 1898, at 22 West Mifflin Street, right next to the Rennebohm's on the corner. When they opened they had a contest in the community to name it, and the Hub was chosen because it was right in the center of the city.

I was raised Catholic. I have an uncle who was a priest. That was a big deal for the family. We lived two blocks away from Blessed Sacrament Church. After World War II, that was an area packed full of kids. If you were Catholic you went to Blessed Sacrament. And we went there from first through eighth grade. There were 52 kids in my eighth grade graduating class and that was with one teacher.

I have lots of memories at our home and in our neighborhood, lots of dolls, lots of creative time. Things were not as structured. There were always eyes on the street because the moms stayed home.

There were not cars on the street. Most people had one car, and they did not drive around very much. We played in the street all

Seen here is a Hub advertisement on the occasion of the store's 10th anniversary. "Conceived on a plan of merchandising that met with popular approval from the very beginning. A uniformly rapid increase in business every year. Today one of the best equipped clothing establishments in the Northwest." (Courtesy of Susan Schmitz.)

This view is of State Street looking toward Bascom Hall in 1954. Susan's favorite movie theaters, the Capitol and the Orpheum, are visible in the middle distance. (Courtesy of Wisconsin Historical Society, WHi-3140.)

the time. I would ride my bike to the grocery store, get the stuff on my mom's list, and she would go in once a month and pay her bill.

"What are we going to do today?"

I liked to sew and do arts and crafts. In those days, kids did not have so many planned activities, so we had to make our own. All of us girls, we were always doing crafts.

Sewing was something that my mom taught all of us. She made a lot of our clothes. When I was real little I learned how to sew by sewing doll clothes. I had a little sewing machine with a crank that I would hook on to a card table. I would turn the crank to sew. Today I have that sewing machine, which I made into a lamp.

On a summer day we would get up and say, "What are we going to do today?" Either sew doll clothes, or we would have rummage sales and sell our doll clothes. We would put posters up all over the neighborhood. We would set our table out in front of our house and sell. Retail was in our blood.

The kids would put on neighborhood carnivals. We would put spook houses in our garages. We would try to sell popcorn. We were always trying to make money somehow. It is kind of funny. A nickel here and a nickel there, selling a doll dress for 25¢ or something, so we could buy material with our money to make more clothes or doll clothes.

Downtown!

The most exciting thing in our lives was going downtown.

We could get a bus at the end of our street. I would go downtown with my sisters to see movies. The Capitol and the Orpheum Theaters were right across from each other on State Street, and right on the corner they had a Caramel Crisp shop. For a dime, you would get fresh popcorn or fresh caramel corn. Movie theaters did not sell concessions, you could just take food in. I thought it would be fun to work in the caramel shop. State Street was really exciting, just bustling with all the cars and activities.

We went downtown for everything that we needed, that was where everything was. I can shut my eyes and I am in Manchesters. Grandma Schmitz would take us one at a time to Manchesters' tea room to have lunch, and they always had these great style shows. I loved the wallpaper up there. It was like scenery, a landscape, very fancy. I would wear my Mary Janes, white gloves and a dress, and carry a little purse.

This started when we were pretty young, like six or seven. She would always buy us some little jewelry or something. I remember the elevators, the man with the uniform and his white gloves. We would stand in the elevator and he would pull the gates shut. I always thought that was so cool.

Manchesters was always busy. The salespeople, especially the women who worked in the accessory departments on that first floor, they were so classy. They were professionals. True salespeople. They knew everybody.

My mother would take us to Manchesters for our Easter outfits. There was a shoe department, and we got to pick out our gloves. My mom always got a new hat for Easter. They had millinery departments in stores, and they always had hat specialists. Sometimes we went to Sibyl's Hat Shop, which was on West Mifflin, where the Shamrock is now. I loved it when my mom let us come with her. She would be at the mercy of the millinery person, they truly helped her pick out her hat. These women were very professional, very dressed up. She would go home with a big hatbox. It is fun to think about.

My parents' world: a business and a nice social life

We all worked in the store in one way or another. We would sweep and clean. The Hub was, at that time, very busy, really bustling. It was a big store. There was a shoe department, and on a second level my dad had a women's department. At 16, I worked there. It was fun, there was a lot of activity.

My mom and dad had a nice social life. They were Badger fans. They would always have parties before the football games and people could walk from our house to the games.

Because of his business, my dad belonged to the Madison Club. We went to some events for the family there. On special occasions, we would go to Rhode's Steak House or the Simon House.

My dad loved music, Big Band stuff, Frank Sinatra. My mom had taken piano lessons

A Manchester window display is seen here in 1954, "for Women who work," perhaps suggesting to Susan a professional career? (Courtesy of Wisconsin Historical Society, WHi-32747.)

and loved music and art, so she had all of us take piano lessons. I was the only one that kept doing it, and now I have the family piano. That was a gift from my mom, a love of classical music.

Media invasion

Television came in when I was seven, that would have been 1956. The programs were not on all the time, so when a show came on, the whole family sat down and watched it. It was real family entertainment. Mickey Mouse, Howdy Doody, Roy Rogers, the cartoons on Saturday morning. Ed Sullivan was a big deal. We all sat around and watched that, our whole family. I remember the first color sets coming, the NBC peacock.

I remember the Beatles invasion. I was a freshman in high school. My high school years were just saturated with great music: the Beatles, The Rolling Stones. I remember when they were on Ed Sullivan. I remember Elvis on the Ed Sullivan show, too. I remember my mom seeing him and saying "Oh my God, that's disgusting," and my older sister saying, "What do you mean, he's cool." The same stuff that goes on today!

"Politics were important in our home"

My parents always voted and we talked about it a lot. I was always interested. I identified with my dad more than my mom. There was quite a bit of discussion when I was 12, when Nixon and Kennedy ran. It was a big deal that there was a Catholic running. Isn't it amazing that was such a huge thing?

We discussed politics at the dinner table. My parents were not liberal. I was a big Kennedy fan, and my dad was a Republican. We had political debates. He would always kid me by calling me, "my liberal daughter." I do not know how I became liberal. I always read the paper. When I was a freshman in high school, I got my own subscription to *Newsweek*. I wanted it just so I could read about politics, I was just curious. I can remember taking my *Newsweek* to school to read in study hall and I had to hide it. I got detentions when the nuns saw it. Can you imagine that nowadays?

During high school, fun and fashion

There were a lot of fun activities for boys and girls. We used to go roller skating a lot. You could do that all day long. It was real cheap and fun. You could roller skate with a boy and he might hold your hand. It was a nice way to

This is Sibyl Hats in 1956, photographed during the evening shopping hours. The sign says "Hats, $1.99, $2.99, None Higher." (Courtesy of Wisconsin Historical Society, WHi-6439.)

Susan's family treasures these photographs of the early Hub department store. This Hub exterior photograph is dated 1898. (Courtesy of Susan Schmitz.)

Seen here is the Hub interior in 1898. (Courtesy of Susan Schmitz.)

learn about guys, pretty simple, pretty easy. We were pretty naïve.

Smoking was a big deal, that was really bad. My dad smoked a lot, about three packs a day. My mom smoked socially. There were always cigarettes sitting around. I look at old home movies and the air was thick with smoke. But then, everybody smoked a lot and smoked all the time. Boy, is that a change in culture.

I went to Edgewood High School from 1964 to 1967. We could not wear slacks, so we had to wear a dress or a skirt. They were really strict about clothes. We could not wear socks, you had to wear hose and flats. Your skirt had to be a certain length.

I made all my clothes. Little suits and dresses, jumpers were the height of fashion, and sweater sets with skirts. I was pretty good at sewing, so my mom had me enter some Singer sewing contests. A suit I made went all the way to state level. I sewed everything, even my prom dress.

I teased my hair and sprayed it. My friends had these great flips. Mary Tyler Moore.

We would wear a little makeup, not a lot. I remember having a pair of Pendleton plaid slacks that I made. My dad got me the material from the store. I was on prom court and I was doing the decorations for the dance. I went home after school and was coming back to hang the decorations, so I put my slacks on. And I was sent home! My mother would get quite frustrated with the rigidity of the rules that the nuns would set.

I had a boyfriend all during high school. On dates we would go to a movie or to somebody else's house. We would always double date. I never got in any serious trouble, we were pretty good kids.

College and beyond during "the War at Home"
I went to Whitewater, then I dropped out and went to the University of Wisconsin. During that time were all the riots. I lived on campus, where the computer data center is now. I was living there when Sterling Hall blew up in 1970. I thought it was world war III. All the windows in our building broke. I jumped

John F. Kennedy is photographed at the lectern during a political speech at the University of Wisconsin Field House in 1960. Susan was a big Kennedy fan. (Courtesy of Wisconsin Historical Society, WHi-8118.)

Susan lived on campus and experienced the Sterling Hall bombing in 1970. (Courtesy of Wisconsin Historical Society, WHi-28381.)

out of bed. I heard the sirens. I was calling all around, it was 45 minutes until I knew what happened. It was really scary.

I was pretty immature when I got out of college. I did not graduate, I just wanted to leave. I liked it but I was bored. I wanted to go into retail. I dropped out and went to work at the store, which I did enjoy a lot. That lead to owning my own menswear business.

When I closed that, it bugged me that I had not finished my degree. I had two years to go. I started again in January 1998, as a first semester junior at 49 years old. I did not graduate from the University of Wisconsin until December of 2000.

It was absolutely wonderful, the best thing I ever did. I felt accepted, the teachers were great—most were younger than I was. They liked having adults in class. I loved the students, they blew me away how smart they are nowadays. They do their work, they come prepared, they pay attention. It makes for a lot better classroom discussion. It was great.

I just needed 27 years to mature. I have been extremely fortunate to have grown up in this city. Madison is so rich with everything,

starting with the people, and the education aspect, it is a great city. You don't get a chance to pick these things. You are born into a family and a place. I am really lucky—not everybody is that lucky.

Susan Schmitz briefly married and gave birth to a daughter in 1977. She became president of Downtown Madison Incorporated while she was finishing her communications degree in rhetorical studies. She lives in Madison with her second husband and enjoys the festive life of the Capital Square where her family's roots go back four generations.

Twelve

REGINA RHYNE, BAYVIEW NEIGHBORHOOD

I was born in Indianapolis, Indiana, on July 16, 1957, the eldest of three girls. My dad is Melvin Rhyne. He is a professional jazz musician. My grandmother, and all our family, are jazz musicians on both sides.

My dad brought us to Madison when I was 11, in May 1969. Madison had a jazz scene, back in the 1960s and early 1970s. He came here because of the jazz. Also, he wanted to get us out of Indianapolis. We had not lived with my mother since I was five.

When I came here, my family was my stepmom, my dad, my sister and myself, plus my stepmom had custody of two of her cousins. We all came here and lived out at Truax. It was scary leaving Indianapolis. We had a lot of family on both sides there. I was leaving familiar surroundings and the church my aunt had us

Regina is seen here at nine years old. (Courtesy of Regina Rhyne.)

baptized in. But once we got settled, it was summertime, and there were activities I enjoyed.

I liked the Bookmobile, I had never seen anything like that. They used to come out to the different neighborhoods, and you would go on the bus and they would issue a library card and check out books. I went through a lot of books back then. I read all the *Little House on the Prairie* books, the *Nancy Drew* mysteries. I loved to read.

And I loved the Art Cart. They had a shed, you could open the shed and play ringers, tie gimp, and all that, I just loved it. My favorite game back then was those little ringers. They had holes in the ground, probably about 12 feet apart, and you would stand on one side and throw the ringer. And if you got it in you got so many points. And gimp, it is a plastic ribbon, it comes in colors on a roll. You braid it for key chains and bracelets and the like.

We used to have a lot of fun playing sports—volleyball, softball, and basketball. My dad would not let us out of the yard in Indianapolis, but in the park behind our apartment at Truax, I was able to play softball. There were a lot of kids in Truax and we had a lot of good times.

And I always was competitive. When I was about 12, this church on Milwaukee Street had a contest. Whoever could guess how many pennies were in the jar got a bicycle. I guessed it. But they did not give me the bicycle. People in the church said, because I was black and it was a white church, I could not have the bicycle. They gave it to a white child. That was one of the first times I experienced racism. That broke me down. Christian people, supposedly!

The MSCR, Madison School Community Recreation, back then they had good people! They took us horseback riding. I had never been on a horse. Nobody told me not to wear shorts! I hollered and screamed, and the horse would not stop, and they tried to calm me down. I have never been on one since. I will watch them, I will bet on them, but I will not ride one.

I went to East High School for seventh and eighth grade. I had friends I went to school with, we had parties. I never had to go to summer school but I always went anyway, for something to do.

In the eighth grade, the U.W. Black Student Association held a contest, and my English teacher put me and another fellow in. I think we had to write an essay or something. We competed, and we won four books!

Strict parents can be hard

My relationship with my dad was hard. I missed my mother. We were always told negative things about her. It was hard growing up.

My stepmom was a good person. She was clean. She fed us and took care of us. But she and my dad were too strict. Really strict. We would be outside playing. My stepmom would say, "Come in, you have to wash every dish in the house." Every cabinet! Everything had to come out of every cabinet, and we had to stand there and wash every piece of it. That was just her way.

My dad—if you did not make curfew, you were in trouble. One time, my sister and I went to a party and stayed an hour later than we were supposed to. Even though we were in the complex, we were in trouble. My stepmom grounded me for three months. No phone, no television. I just read.

We yes ma'am-ed. We did not talk back. Kids these days? My daddy would not have had it.

We ate good. My dad used to cook. I can see him standing in his undershirt. He would make cream of wheat, he would make oatmeal, he would make rice. And I eat that to this day, and feed it to my kids and my grandkids. They love it. Rice with sugar and butter and milk. My daddy was a good cook. My stepmom made good plum cobbler, though. It was delicious!

My daddy used to take us fishing. We would pack up a lunch. We would go out to Yellowstone Park, or up to Beaver Dam. He taught me how to catch the fish, how to clean the fish, how to cook the fish. We would get in the car, we would be gone all day.

They used to take us to the drive-in movies too, out at Highway 51 and Stoughton Road. It was a hop, skip, and a jump from Truax. We went often.

My dad said, "If you want it, you've got to earn it"

I always liked going shopping. When I was growing up, they had Kresge's on the Square, they had Woolworth's. My dad was the type of man who said "if you want it, you've got to

Regina's father, Melvin Rhyne, is seen at the piano, playing at a festival. (Courtesy of Regina Rhyne.)

earn it." It used to tick me off. But he instilled in me a good work ethic, I will say that.

I got my first job babysitting when I was 11. Later, I worked at Rennebohm's. When I got my money, I used to go and buy my nylons, and I would buy my bubble gum, and I bought 45 rpm records. My daddy did not like rock-and-roll, R&B music. He did not want me to play my music. He was strictly a bona fide jazz enthusiast, and still is to this day.

There was not black radio here like there is now, and I grew up listening to the Beatles and Elton John, and the Doobie Brothers and the Average White Band. That was all we had on the radio.

I used to buy a lot of comic books. *Archie* was my favorite. You know how you read and you put yourself into the story—the one girl was pretty, the other girl was kind of plain. But she was the cool one and the other could be kind of snotty. You take those characters and you see life, you know how you want to be in the future, when you have a romance or whatever.

The move to Bayview
In about 1971, when I was about 14, we moved from Truax to Bayview. They had the buildings up in the back but they had not even finished the sidewalk. All that was there, after the city destroyed the old Greenbush houses, was the elderly housing next to the new Bayview building. The rest of the area was flat grass, so that was where we played. There wasn't the grocery store there, no clinic, just grass. Look at how it has changed.

Bayview was a great neighborhood. You had the beach across the street. Neighborhood House wasn't too far, we were able to go there and play basketball, participate in programs. They have summer activities and field trips. We would go to Milwaukee and play ball. They took us swimming, to the Dells, stuff like that.

I spent a lot of time at the South Madison Neighborhood Center. The gym always used to smell because it was small, and you know people playing ball—it was funky. But I loved it.

I used to dream about getting away from my parents because they were so strict. Or I dreamed about having things we did not have.

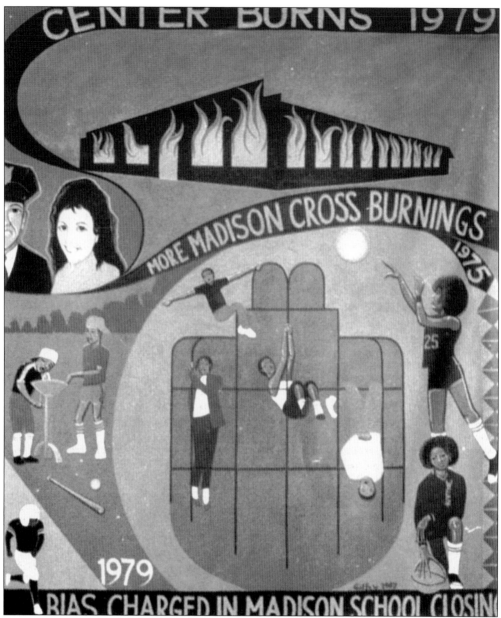

Seen here is a mural at the South Madison Neighborhood Center showing Regina and friends. Regina is in the lower right. (Courtesy of David Giffey.)

At that time I did not know, but we were on welfare. I did not know that AFDC stood for "Aid to Families with Dependent Children." We would joke that it stood for "After Daddy Cut Out." We were making fun of ourselves.

High school

I started high school at West High School in 1971. I lettered in three sports: volleyball, basketball, and softball. I was on the debate team. I tried to be involved in as many activities in school as possible. Mary Henderson, Dena Wright, Tempest "Tippy" Hargons, Dawana and Charmaine Smith, we all played ball. If you go to the South Madison Center, there is a mural up there. I am the one kneeling down and Dena's the one making a jump shot.

I loved school. I was a good student. I always thought I was going to be somebody out there. I liked John Kennedy, and Robert Kennedy, and Martin—I liked reading about them in the paper. I needed to know what was going on.

They used to tease me a lot as a kid. They were probably jealous, now when I look back on it.

I had an afro, real kinky hair. Big. I used to wear dresses. Which is good, I think girls should. I would wear a skirt and a blouse. I wore pants too, and when it got warm I could wear shorts. Chuck Taylors were big then. So I always wanted Chuck Taylors because I played basketball.

Running to a better home

Then my stepmom beat me so bad, I ran away.

My dad left Madison when I was 15. I did not want to go to Milwaukee with him. I was doing good in school.

I was with my cousin Riki and I bought some make-up. I did not even really wear a lot of make-up. When I got home, her stepmother was there, with my stepmom, and they started fussing at me about this make-up I bought for Riki. My daddy was gone, he had to do a gig, they call it. My stepmom reached back to hit me. I was standing by the stairs. I was afraid to fall down those stairs. I got a whipping that day.

I went in my room and grabbed this big pink pig I had won at the fair. I held onto my pig. My aunt and cousin went home. When my stepmom was sleeping, I snuck out. I just snuck down the steps on my behind, real quiet. I was out the door, and I ran! I remember it was the Fourth of July, because I was standing over there on Mills Street waiting for the bus, and the bus never came. Then I realized it was a holiday.

I was scared, because I was not that far away from Bayview yet. I forget how I got to Mary Henderson's house, but I know I called her. I went out there and stayed a couple days.

I did not take anything but the pig. Mary gave me something to wear for a couple of days. Her mom at first did not know I had run away. Mary told her I was visiting. Finally I turned myself in.

I went to Dane County. David Rustig sat with me. I told him if he was going to send me back home, I was going to jump off a building, because I could not take it there.

He sent me to live with a lady on the east side. She had a little boy about three. He kept going in my room, messing with my 45s and stuff, I did not like that. So Mrs. Henderson got her foster license and I went to live with them. She became my foster mother and still is my godmother to this day.

When I was in high school, I liked white boys. I am just going to tell you honestly. There were some fine white boys in my school. I liked the black guys, too, but we were taught keep your legs closed, keep your dress down, that kind of thing, and I really did not get too fast or flirtatious until I got older.

Some kids were drinking, doing drugs then, of course. Not so much in the neighborhood, more at school. Back in the day it was Bacardi and Coke, Boone's Farm, Wild Irish Rose, if you were strong, or MD20-20. And we used to drink a lot of wine coolers, a lot of sugar and a lot of alcohol. I remember one time, I went to some white kids's party downtown. I got blasted, and I fell asleep, and the boys watched over me all night long.

But back then, you know, people smoked pot. There were people that had speed and LSD and all that, but I was too fearful to do that.

At West High School, I was involved in an incident and the girl was white. I was the one that got suspended. She called me a b—, and I popped her. Milt McPike was my principal. When I came back to school she did it again and I hit her again and was

Regina is seen in a photo booth portrait at 17 or 18 years old. (Courtesy of Regina Rhyne.)

Seen here is Regina's high school graduation portrait from 1975. (Courtesy of Regina Rhyne.)

suspended again. When I came back that time, I had learned my lesson. I am not a physical fighter, but I will fight you with words in a heartbeat.

But then, Mr. McPike helped me get a job working at Forest Products Lab. It was the last semester of my senior year. I did clerical work, got paid decent too, for a kid.

When I graduated from high school, my grandmother came up with my aunt for my graduation. She asked me, could this lady come to my graduation. It was my mother! I about fainted. I had not seen her since I was nine.

Mount Zion and "the Mothers"
When I lived with Mrs. Henderson, she made us go to church. I got in the choir at Mount Zion Church.

I like gospel music. Walter Hawkins, Tremaine Hawkins, Dannibelle, back in that day, we used to sing a lot of Walter Hawkins songs. Leotha Stanley was the piano player, and I used to get to sing the lead! When I look back at the church, the ministers we have had, Rev. Joseph Dawson, Rev. Joseph Washington, Rev. James Wright, Mother Jackie Wright, they were good people.

People dressed up for church. Back in those days, a girl wore a dress, and nylons, there were certain shoes. I mean, you wanted to look holy, and I am not saying that to be funny, it was a different time and day. Women did not wear pants in church when I was a teenager, they did not until really recently, I would say 1995 or so, in our church.

We used to have a lot of Sunday dinners after church. The meals! We would eat chicken, ham, mashed potatoes, green beans, greens, candied yams, corn, some kind of bread, all kinds of desserts, I mean they would make pound cake, and all kinds of pies, and peach cobbler, oh my goodness. Either Mother Henderson or someone else would be in there, cooking like they do now.

I remember that Daddy King (Dr. Martin Luther King Jr.) came here when I was probably 17, almost 18. There was a whole bunch of us lined up in front of the altar, during church, and even in the basement watching on closed-circuit television. We all joined church that day when Daddy King was here.

"I always had a political heart"
I had a job on the Neighborhood Youth Corps for the old Department of Civil Rights. I worked with people with civil rights movement history there. I was glad to be able to have that job, it exposed me to a lot.

I always have had a political heart. When I was 18, I ran and I got on the board at the South Madison Neighborhood Center. I found out there was a board that made all the decisions about what we did all day. I spoke out. I would get up and I did what I thought represented the teens best.

I stayed on that board off and on for 12 years, because I cared about the community, the direction it was going. I wanted the kids to have wholesome activities and I wanted to be involved in the decision-making. It was the birth of my life in politics.

Taking on college, motherhood, and social justice
After graduating high school, I started at the U. W., I went into behavioral disabilities. I got pregnant, I got tired. I was in school every time I got pregnant, that was one thing. That did not stop me from going to finish my education.

When I was younger, I always knew I was going to have kids. I hoped to have a husband and I did not, but I love my kids.

During that time, I must have been 21 or 22, I got a job working with the old Wisconsin Council on Criminal Justice (WCCJ). I met Barbara Franks there. Barbara sent me to a conference at the University of Wisconsin, Milwaukee. It was about social justice, black teens and stuff like that. That exposed me to a whole new realm.

At the U. W. I did 22 credits in behavioral disabilities. Then I went to Madison Area Technical College (MATC). I went into police science, I think because of the criminal justice background they gave me at the WCCJ. I was the first black female to graduate in police science from MATC, in 1980.

Then I went to the university and studied sociology with an emphasis on correctional administration, because I felt I was going to be a warden or something like that.

By that time, I had two kids, and then I had Nellieyah in 1983. I got my degree in December 1983. I worked too, sometimes I

Regina is photographed with her father's mother, in the late 1970s. (Courtesy of Regina Rhyne.)

had two or three jobs. I do not know how I did it.

The following year, they had recruitment for the Dane County Sheriff's office. Somebody told me and I wanted to do the doggone thing, so I went on over there. I was the first black female hired by the Dane County Sheriff's Department, in June 1984. It was exciting for me.

I was a cop with the Sheriff's office. I passed all my classes, got to the 17th month, it was November 1985.

I came to work one day, I had passed my written test, and at 18 months I could be a sheriff for real. Whoever was the head back in that day, I came in and he told me "take your badge, your gun, give it up. You don't fit in." That broke me so bad—it broke me! I was bewildered. I was doing my job. White folks did not like black folks being in positions like that.

Then I said, well, I am going to keep trying to get a different job, stay busy, raise my children.

"A lot of history here"

Mount Zion Church warmed my heart. They always had the mothers and the deacons, but for a long time, you did not have women in the pulpit. I like how that has evolved. In the 1990s, Mother Clara Franklin became the first woman deacon in our church. Now women are getting positions of authority. These women are dynamic! You got women up there now, they can just preach! There is a peace, a solace that you find when you go to church.

I always liked to read the newspaper because I wanted to know what was going on. There was a day when I had to have my *State Journal* and my *Cap Times*, to see how they changed the story.

When we moved here, Vietnam was still going on. I remember the guys in the helmets, the National Guardsmen, messing with the students on campus. I saw it! It was frightening, because they had batons and things, they were hitting the kids.

I look at Madison now, I see the way it has grown. It used to be so green. So much land, open space! The urban sprawl has changed Madison. In some ways for the good, but I do not think your average families are going to be able to buy houses around here.

I had some good role models coming up. Men at the youth center, but more, the women in my neighborhood and church. These ladies saw me and they encouraged me. They were really influential with me caring about kids. Around them, you could feel an "it takes a

village to raise a child" mentality. When you did something, it came back to hit you at home.

Mount Zion Church, the South Madison Neighborhood Center—there is a lot of history here.

Regina Rhyne found work in Wisconsin's state government including stints with the Division of Vocational Rehabilitation, the Department of Health and Social Services, the Department of Industry, Labor and Human Relations, the Department of Natural Resources, and the Department of Revenue. "I learned a lot working for the state: about economic development, about how to go from point A to B in a bureaucracy."

Regina has continued to pursue her interest in social justice both politically and personally. She was elected Dane County board supervisor of District Thirteen in 1994. While in office, she pursued every opportunity to support minority entrepreneurs and economical development for the disadvantaged neighborhoods of Madison.

More recently, she completed a real estate license, winning a Partnership for Success award from the Wisconsin Realtors Association. She is an active member of Mount Zion Baptist Church and enjoys spending time with family and friends when her busy career permits.

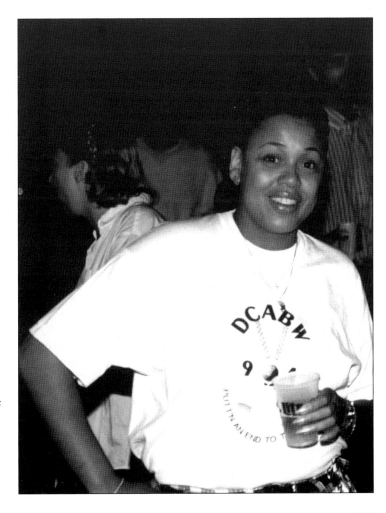

Regina is photographed at a Dane County Advocates for Battered Women fundraiser in 1994, just after she was elected Dane County supervisor. (Courtesy of Regina Rhyne.)

AFTERWORD

I hope you have enjoyed spending time with my newfound friends: Ruby, Helen, Anne, Rosemary, Anita, Donna, Jackie, Winnie, Margaret, Beverly, Susan, and Regina. I am grateful for all I have learned from them in the course of the conversations that went into this book.

I hope above all that I have conveyed the respect these women feel for their mothers. Almost all of the women I interviewed said to me, at one time or another, "I want you to know how hard my mother worked." These women form a link between generations, experiencing a wider world, and one with much less manual labor, than their mothers knew.

From Ruby's afternoons in 1926, spent helping her mother take care of their boarders, to Susan in 1956, free to "play retail" with her sisters, we watch women move beyond the daily cycle of chores that tied them to small horizons. From Anne, who was not allowed to swim or ride a bike, to Winnie moving into an apartment on her own, to Regina's "firsts" in education and employment, we watch women's freedom expand and we see that this progress is good.

But what have we lost as we have moved forward? These women miss the prettier, friendlier, greener place that was the Madison they grew up in. They are nostalgic for a time when family spent more time together.

All are sad about the demise of the Downtown retail experience that was such a vibrant part of Madison life. They fondly remember certain stores and the friendly, knowledgeable service they received there.

As I reflect on these women's stories, I see one aspect of Madison that seems unchanged and unlikely to change, an aspect I deeply appreciate. Madison has always welcomed different people and offered them an opportunity to succeed as part of our community. The waves of immigrants arrive—whether from near or far—find their places in the fabric, and get to work improving their prospects. While I am sorry I never saw the original Greenbush neighborhood, I like it that Anne's Greenbush becomes Regina's Bayview, a neighborhood that retains its purpose of welcoming and blending its residents into the larger community.

I love it here, even more so now that I have the perspective of these women's memories. I hope you do too.

INDEX

ACROSS AMERICA, PEOPLE ARE DISCOVERING SOMETHING WONDERFUL. *THEIR HERITAGE.*

ARCADIA PUBLISHING IS THE LEADING LOCAL HISTORY PUBLISHER IN THE UNITED STATES. WITH MORE THAN 3,000 TITLES IN PRINT AND HUNDREDS OF NEW TITLES RELEASED EVERY YEAR, ARCADIA HAS EXTENSIVE SPECIALIZED EXPERIENCE CHRONICLING THE HISTORY OF COMMUNITIES AND CELEBRATING AMERICA'S HIDDEN STORIES, BRINGING TO LIFE THE PEOPLE, PLACES, AND EVENTS FROM THE PAST. TO DISCOVER THE HISTORY OF OTHER COMMUNITIES ACROSS THE NATION, PLEASE VISIT:

WWW.ARCADIAPUBLISHING.COM

CUSTOMIZED SEARCH TOOLS ALLOW YOU TO FIND REGIONAL HISTORY BOOKS ABOUT THE TOWN WHERE YOU GREW UP, THE CITIES WHERE YOUR FRIENDS AND FAMILY LIVE, THE TOWN WHERE YOUR PARENTS MET, OR EVEN THAT RETIREMENT SPOT YOU'VE BEEN DREAMING ABOUT.